¡REVOLUCIÓN!

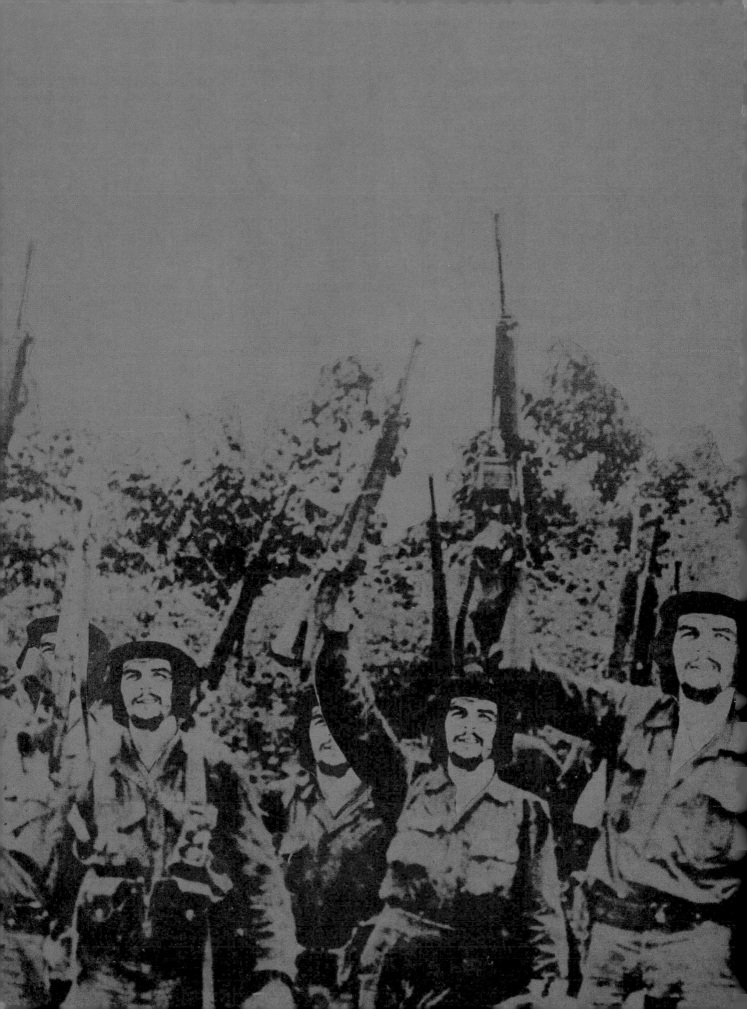

¡REVOLUCIÓN!

CUBAN POSTER ART

Lincoln Cushing

CHRONICLE BOOKS

SAN FRANCISCO

Pages 130–131 constitute a continuation of the copyright page.

Library of Congress Cataloging-in-Publication:
Cushing, Lincoln, 1953–
¡Revolucion! : Cuban poster art / Lincoln Cushing.
p.cm.
Includes bibliographical referencea and index.
ISBN-13: 978-0-8118-3582-4
ISBN-10: 0-8118-3582-0
1. Posters, Cuban—20th century. 2. Cuba—Politics and government—1959–
3. Art and state Cuba. I. Title
NC1807.C8 C87 2003
741.6'74'09729109046—dc21 2002035092

Design by Santiago Giraldo at Cuartopiso SF
Manufactured in China

10 9 8 7 6 5

Chronicle Books LLC
680 Second Street
San Francisco, CA 94107
www.chroniclebooks.com

CONTENTS

INTRODUCTION

From the mid-1960s through the early 1980s, Cuban graphic artists produced posters of enormous artistic power and social impact. A unique confluence of conditions fueled this prolific output—a small and literate nation immersed in the heady rush of building a new society, a dense community of artists willing to explore popular media, a state that actively supported the arts, and a highly centralized political apparatus anxious to consolidate power. The energy of a new film industry sparked the process, and by the time the Soviet Union collapsed, Cuba had produced at least twelve thousand posters on such wide-ranging subjects as occupational health, the sugar harvest, the war in Vietnam,[1] glass recycling, and folk music festivals. Cuba is a small enough country that posters are a viable medium for reaching a wide audience, and mechanisms created for the dissemination of other social goods readily took on the selective scattering of these vocal graphics. Some of the posters (such as those announcing film showings) were limited-edition publicity items, but most were generated in the thousands and freely dispersed like dandelion seeds all over Cuba and the world. Many ended up in union halls, community centers, schools, and private residences in Cuba and beyond.

These posters offer a glimpse into Cuban life. Impressive as they are as artistic artifacts, their deeper value lies in their ability to help us understand the Cuba of this period. It was one of those historical moments when human capital was more important than financial capital, when public voluntarism was commonplace and self-sacrifice expected. Social experimentation was the order of the day. Many people's lives were fundamentally changed, and old political struggles were resolved as new ones emerged. The overthrow of Fulgencio Batista and the immense national transformation that followed led to a "golden age" of Cuban posters.[2] The noncommercial mass poster was the direct fruit of the revolution, a conscious application of art in the service of social improvement. State resources were allocated as never before to a broad range of cultural and artistic projects, and posters were the right medium at the right time. These posters were indelibly steeped in this revolutionary brew, and these images deserve to be not just seen, but understood. It is my deepest hope that this book will help broaden appreciation of Cuban culture and promote a more informed debate.

LUIS MARTÍNEZ–PEDRO
(original title unknown) Two Rifles
1955 54 x 24 cm silk screen

THE CUBAN POSTER TRADITION

"Within the revolution, everything; without it, nothing."[3]
—*Fidel Castro, 1961*

Although this oft-repeated quote by Fidel Castro would seem to suggest a heavy-handed policy of cultural orthodoxy, Cuban cultural practice is in truth far more complex. Cuba is a literate nation of eleven million people; Havana itself is a cosmopolitan capital of one million and has been a nexus between the Old World and the New ever since the "discovery" of the Americas in 1492. From the beginning, Cuban artists and intellectuals have been active in creating their own national culture. During the intense period before the 1959 revolution, artists of all stylistic persuasions were using their skills to help overthrow Batista. My mother, Nancy Cushing, once told me a story from that period that illustrates the sort of engagement that involved artists of all styles. In 1955 an abstract painting with the innocuous title *Piece #2* by Luis Martínez-Pedro won top honors at a national art exhibition in Havana. After a wealthy New York collector purchased it, it was reproduced as silk-screen multiples as a fund-raiser for Fidel Castro's revolutionary forces. Its newly revealed underground title? *Two Rifles.*

"Our enemy is imperialism, not abstract art."[4]
—*Fidel Castro, 1977*

Early progressive social movements, including the American and French Revolutions, relied on the power of printed broadsides and posters. Many other distinctive political poster genres had emerged around the world by the time Batista's power was shattered in Cuba. Among them were the prints of José Guadalupe Posada that energized the Mexican revolution of 1913–1915; the Mexican posters generated by the Taller de Gráfica Popular (Popular Arts Workshop), founded in 1937; and posters produced by the revolutionary governments of the Soviet Union and China. What distinguishes Cuban poster art from these antecedents is its wide range of content and style. This is the result of several factors, including a long tradition of international influence in Cuban artwork and a revolutionary government that was relatively open to experimentation and innovation.

As in Europe and the United States, commercial lithographs first appeared in Cuba during the mid-nineteenth century. The emergence of a booming film industry in the 1940s—and the need to

加速农业机械化的步伐　为农业现代化而奋斗

publicize those films—led to the first distinctly domestic advertising poster style. In 1943 the exhibit *Originales de Tamigraph: Silk Screen Originals*, which included fifty-five works by twenty-seven North American artists, provided a significant impetus for the recognition in Cuba of fine-art screen printing.[5] During the 1950s a few artists applied their talents to printmaking, but it remained a lesser cultural form than painting or sculpture until after the revolution. Even in the years immediately following 1959 there was no particular sign that this art form would blossom. Early public artwork was generally described as unimaginative and hackneyed; in the words of one observer. "Commercial standards of realistic illustration of the Batista era were [simply] given a new political orientation."[6] However, artists, writers, and other intellectuals began to criticize this trend, and alternative approaches flowered. On July 26, 1969, the first of many Salónes Nacionales de Carteles (National Poster Salons) was held, juried by prominent designers such as Umberto Peña and Adelaida de Juan, and the medium itself began to achieve legitimacy.[7] Perhaps more important, the Cubans managed to avoid mimicking the socialist realism typical of Soviet and Chinese propaganda and were well on the way to establishing their own unique style. Given that the two countries were in the process of building deep political and economic ties, this was a highly visible indicator of Cuban independence. In order to understand exactly how the poster art form came to prominence in Cuba we must look at the major contributors to this movement —the publishers and artists.

THE PUBLISHERS

The vast majority of Cuban posters have been produced under the auspices of three agencies: ICAIC (the Cuban Institute of Cinematic Art and Industry, more commonly known as the Cuban Film Institute), Editora Política, and OSPAAAL (the Organization in Solidarity with the People of Africa, Asia, and Latin America). Although each agency developed its own area of specialization, individual artists often created work for all of them.

ICAIC has a silk-screen workshop that is responsible for producing posters for all films made in Cuba, as well as for foreign films shown in Cuba. Its posters have all been of identical size to fit in special kiosks throughout Havana and other cities. To reach Cuba's large rural population, mobile projection crews also show films in the countryside. Movies have always been enormously popular in Cuba. Before the revolution, film posters, like the films themselves, usually were designed and

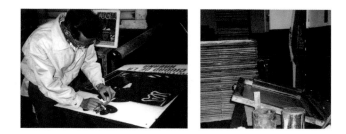

Cutting stencil for poster reprint, ICAIC silk screen shop, 1993

ICAIC silk screen shop, 1993

printed outside the country. The first real breakthrough in establishing a domestic graphic presence occurred in the early 1940s, when the commercial graphic artist Eladio Rivadulla Martínez and other Cubans began to create silk-screen movie posters specifically for the local market. This trend took a dramatic step forward after the revolution. ICAIC is generally acknowledged as having been the prime force in the postrevolutionary emergence of a uniquely Cuban style of poster art. Saúl Yelin was a visionary publicist when ICAIC was created in March 1959, and he was instrumental in turning the fresh, new film institute into a significant international cultural presence.[8] In keeping with the spirit of the times, the contribution of individual artists was seen as less important than a poster's content, and dozens of idealistic and talented artists applied their professional skills to this new enterprise. Given that film showings were already well attended, however, the posters were not as much advertising as they were an opportunity to present a Cuban slant on a film's subject. ICAIC is the only one of the agencies that actively marketed its posters as a commercial product. It maintained a small retail store in Havana and sold many posters in the local and international markets.

Editora Política (EP), the official publishing department of the Cuban Communist Party, started out as the Commission of Revolutionary Orientation (COR, 1962–1974), then became the Department of Revolutionary Orientation (DOR, 1974–1984), and finally settled on Editora Política in 1985. This agency is responsible for a wide range of mostly domestic public-information propaganda in the form of books, brochures, billboards, and posters. Many other government agencies used the resources and distribution powers of EP for their own work, including the Federation of Cuban Women, the National Confederation of Workers, and the Latin American and Caribbean Student's Association.

OSPAAAL logo

OSPAAAL (Organization in Solidarity with the People of Africa, Asia, and Latin America) is officially a nongovernmental organization (NGO) recognized by the United Nations and based in Havana. It was once the primary source of solidarity posters produced in Cuba and aimed at activists around the world. Between 1966 and 1990 OSPAAAL published *Tricontinental,* a monthly magazine with a circulation that peaked in 1989 at thirty thousand and reached eighty-seven countries. *Tricontinental* was produced in four languages (English, Spanish, French, and Arabic), and many issues—especially during the early years—included a poster. This simple act, of violating the conventional formal purity of a poster by folding it up for mailing, was the key to what became the most effective worldwide poster distribution system ever. Some posters

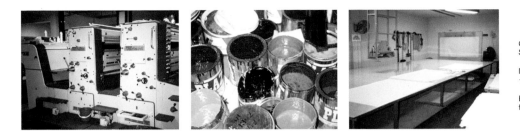

Offset press at EP's Taller Abel Santamaria, Havana, 1989

Inks at EP's silk screen shop, 1989

EP's silk screen production facility, 1989

were even designed to take advantage of this process, presenting different or modified images as the viewer unfolded the mailer. OSPAAAL produced posters covering about thirty-eight nations and a wide range of subjects, including the British war against Argentina over the Falkland Islands (the Malvinas), the anniversary of the nuclear bombing of Hiroshima, and nineteen posters on Che Guevara. Although OSPAAAL's publishing activities have been drastically reduced in recent years, the organization continues to host international conferences.

There are, of course, other venues for poster production in Cuba. ICAP, the Cultural Institute for Friendship between the Peoples, has a small offset shop. The Taller Artístico Experimental de Serigrafía René Portocarrero, founded in 1983, is a fine-art studio in Havana always abuzz with students and teachers. Printmaking continues to be a medium of choice for many artists. Other agencies, such as Casa de las Américas, create many posters for exhibitions and conferences. Finally, there are small job shops that produce work for commercial clients, a sector that has grown dramatically in recent years because of increased foreign investment in the country.

THE ARTISTS

The Cuban artists themselves, as individuals and as a group, played a central role in the vibrant cultural explosion of Cuban poster art. Some—like Eduardo Muñoz Bachs and René Mederos Pazos—were staff designers; others contributed as freelancers. Each one brought a particular style that was generally encouraged, rather than subsumed, in the design process. Most had formal training as designers (Félix Beltrán) or painters (Raúl Martínez). Each left an indelible stylistic mark. Bachs, whose work as a children's book illustrator was influenced by Polish posters, adopted a decidedly whimsical and loose approach. Martínez is generally credited with introducing the "pop" style to Cuba. Beltrán's work is characterized by elegant simplicity. Alfrédo Rostgaard was able to inject the unexpected into images that had been exhausted by previous artists. Mederos was a master at combining painterly flat fields of color with exquisite line work, and Alberto Blanco explored photomontage in many of his OSPAAAL posters.

Cuban designers were not immune to the tension between artist and client, however, and almost every designer has anecdotes of creative work thwarted by political inappropriateness or bureaucratic thickheadedness. Even the simple issue of artistic recognition was an object of

struggle among designers and agencies. Still, many posters were signed or otherwise credited, an uncommon characteristic in state-sponsored socialist art. As art director of OSPAAAL, Alfrédo Rostgaard held the opinion that posters should be signed, "Because the people want to know."[9] Of the graphic artists active between the 1960s and the 1980s, about one-third have died, one-third have left the country for various reasons, and the remaining third continue to make a living in Cuba.

WOMEN GRAPHIC ARTISTS

Despite the efforts of the Cuban revolution to empower women and achieve socialist equality, the work of women artists is very unevenly represented among the thousands of posters produced since 1959. Eight women—Berta Abelenda, Gladys Acosta, Estela Díaz, Clara García, Daysi García, Jane Norling, Asela Pérez, and Elena Serrano—designed 22 of OSPAAAL's known output of approximately 326 distinct titles (less than 7 percent). Although Serrano and Pérez each created only one image for this agency, their posters were among the more memorable—the famous *Day of the Heroic Guerrilla (Continental Che)* and *International Week of Solidarity with Latin America,* respectively. Jane Norling, a muralist and graphic artist from the San Francisco Bay area, designed one while she was working there in 1973. Every single one of Berta Abelenda's posters included some form of weapon, ranging from spears to bazookas, always treated in a witty and unexpected manner, as in *Day of Solidarity with the Arab Peoples.* Interestingly, although ICAIC saw prolific output, it appears that only a handful of its posters—as few as four—may have been designed by women. These include *Historia de una chica sola,* by "Cecilia," in 1970; *Las secretas intenciones,* by "Clara" (García?), released the same year; *La separacion,* by "Clara," in 1971; and *La tierra,* by "Asela" (Perez?), in 1974. Many of the women who designed posters for OSPAAAL also did so for EP, including Gladys Acosta, Estela Díaz, Clara García, Daysi García, and Asela Pérez. Other designers included Eufemia Alvarez, Isabel Carrillo, Cecilia Guerra, and Vivian Lechuga. Of the 218 EP posters I have cataloged, 35 (15 percent) were designed by women.

THE NUMBERS

It is difficult to assess the number of distinct posters printed in Cuba since the revolution. One way to determine the figure is to survey production counts at the source, from the agencies that

Posters on the wall of a pharmacy in Havana, 1986
(photo by Cindy O'Hara)

produced them. Of the three major publishers, the output for OSPAAAL is most accurately known, since it is the smallest and also because it is now the most thoroughly cataloged as a result of my documentation efforts. Both ICAIC and EP have far higher numbers, yet still remain poorly researched. Editora Política kept relatively thorough records, but ICAIC's documentation is less organized and authoritative. And of course, there are the many posters produced by smaller publishers, such as Casa de las Américas, Verde Olivo (Olive Green, the armed forces press), and ICAP.

Based on a twentieth anniversary list of a thousand posters, ICAIC's output shows a slow growth, peaking in 1974 with 169 titles, followed by a gradual decline.[10] Although this list implies inclusion of all posters created during those years, some checking against other sources reveals that many titles are absent. For example, records for a single artist (Alfrédo Rostgaard) show that he designed at least 7 posters beyond the 19 listed for 1965, and 19 posters more than the 28 listed for 1966.[11] This degree of error could easily indicate the counts are low by as much as 50 to 100 percent, meaning that for the years covered the actual output could have been closer to 1,500 to 2,000. The production peak reflects a rise and decline corroborated by anecdotal evidence; current production of new titles is minuscule, similar to what it was during the agency's first eight years.[12] Extrapolating at 60 per year for 1979–1989 (600) and 20 per year for 1990 2000 (200) would mean that ICAIC's total production to date is between 2,300 and 2,900 distinct titles.[13] The cumulative total of distinct OSPAAAL titles appears to be around 326, peaking with 43 posters in its second year of production and slowly dropping to fewer than 5 a year since 1984. The figure for EP's output is hardest to quantify because thorough research of its records has not yet been done. Its production figures are unknown, but probably number around 6,000 to 8,000.[14] Beyond this, there are the numerous, but uncounted, posters produced by small state agencies, including the 3 mentioned previously.

STYLE

The posters in this book were selected out of thousands to reveal certain consistent characteristics of Cuban design. Although a tremendous range of styles is evident among them, certain patterns emerge that help to describe this body of work. Perhaps the most surprising is the

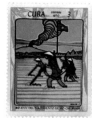

RENÉ MEDEROS, 1970

low quotient of socialist realism—the relative absence of heroic, amped-up superworkers and pro-duction equipment so prevalent in the revolutionary artwork of the Soviet Union, China, and other communist countries. Rather, Cuban artists used alternative and creative approaches to graphic representation, producing a distinctive and rich poster genre. Some of the stylistic features displayed by these posters are:

Illustration and graphics. Very few of these posters use photographs as source elements or rely on full-color reproduction of original art; almost all are based on what is known as "flat color" in the graphic arts. This stylistic convention is due in part to the technical limitations of hand-cut silk-screen stencils, but a more complete explanation would have to include a fondness for this particular graphic treatment on the part of the designers, since many posters were reproduced in offset.

Humor and visual wit. Overt satire, such as in *Visit Grenada,* and subtle wit of imagery, like Che Guevara's repeated faces in Rostgaard's *Many Ches,* represent accepted design approaches. This also includes the tactic of fusing disparate images, like the two-way radio, grenades, car-tridges, and bazooka neatly drawn in classic Egyptian style in *Day of Solidarity with the Arab Peoples* or the hand grenade knight's torso in *Army Chess Tournament.*

Weapons. Many Cuban poster artists use the imagery of weapons, from spears to AK-47s, to symbolize the ultimate extension of political power. After experiencing a major revolution less than two generations ago, Cuba has had to continue to defend itself against armed attacks from the United States government and militant members of the Cuban exile community. In addition, for many years Cuban foreign policy actively supported revolutionary movements around the world, and Cuba sent regular army troops, clandestine forces, and arms to many countries. Weapons can show up in obvious settings, such as posters expressing solidarity with nations in struggle, as well as in less obvious situations, such as *First Conference on UNEAC* [the National Writers and Artists Union] *Graphic Design,* or the poster for the tenth anniversary of ICAIC. In some cases, the use of indigenous images is fused with modern weaponry, as in posters on Guatemala or the Arab people. The type of weapon also has a political dimension; sophisticated hardware, such as missiles and fighter jets, is always associated with the forces of oppression and imperialism.

Conceptual abstraction. Many of these posters elegantly demonstrate the designer's ability to reduce abstract concepts to simple images, as evidenced in the representation of anti-imperialism, anticolonialism, or the power of organized resistance.

Appropriation. In several examples, well-known or popular artwork is radically transformed, for

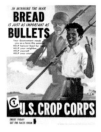

example da Vinci's classic human form in *Capitalism—Denial of Human Rights* or the traditional religious painting genre represented in his untitled Guerrilla Christ poster.

Iconography. Many posters use commonly understood visual shorthand to express their subject. Icons include Uncle Sam, the imperial eagle, the dollar sign, continental shapes, stylized flags, and machetes.

CONTENT

Although the separate "fine art" and "commercial art" worlds continue to exist in Cuba, significant amounts of resources and talent were funneled into challenging that dichotomy. Instead of selling products, Cuban artists could actually make a living using their skills to promote services and build community. Posters publicized motorcycle-based health brigades, exhorted citizens to join the sugar harvest, advocated efficient work in the sugar mills, and encouraged planting healthful fruits and vegetables on available land. Some crops, such as tobacco, require a challenging balance of public policy approaches; one poster pleads for "Your youthful hand" in helping the harvest, but another warns, "Tobacco burns health." Sports, education, and culture all play significant roles. One poster for an armed forces chess tournament displays a commitment to playing for keeps; another proudly proclaims, "I am going to study to be a teacher," and a third uses a decidedly take-no-prisoners approach in promoting a conference for writers and artists.

International solidarity is an important part of the national culture, especially because Cuba has had its own long fight against foreign domination. This deep connection to other underdeveloped countries struggling for self-determination resulted in many works succinctly and elegantly conveying resistance to colonialism and U.S. imperialism. In 1969, and again in 1971. Editora Política sent the artist René Mederos to Vietnam, where he spent several months experiencing the American war on the ground. He created two stunning series of paintings, many of which were turned into silk-screen prints and offset posters. The Cuban government also issued seven as postage stamps based on these posters.

The persistent theme of *As in Vietnam* underscores a deep national determination to be as self-reliant, brave, and resourceful as the people of Vietnam, equating domestic food and industrial production with the urgency of armed struggle. This theme, of a nation surviving under siege,

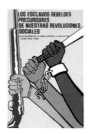

RAUL F. CRUZ
*Rebel Slaves—Forerunners of Our Social
Revolutions / Centennial of the Abolition of
Slavery, Cuba 1886–1986*
1986 EP (DOR-Matanzas) 62 x 39 cm silk screen

largely reflects the economic and political reality of U.S.–Cuban relations and has artistic precedents in posters produced in the United States during the Second World War.

Many posters include visual references to Africa and to the struggle against slavery and racism. Cuba is an extraordinarily racially integrated country, a feature that can be traced to wars of independence in which trust and respect between Spanish-origin criollos and Afro-Cuban leaders and troops were essential to victory against the Spanish. A 1986 poster commemorating the centennial of the abolition of slavery is titled *The Rebel Slaves—Precursors of Our Social Revolutions,* which articulates a theme repeated through many Cuban posters. Africa is a popular subject of films, as are slave revolts and solidarity with forces fighting the slave trade and colonial legacy in Africa and the Americas. Historical events from Cuba's own revolution are also regularly portrayed, including the 1953 attack on the Moncada barracks, the 1955 voyage of Fidel's forces from Mexico to Cuba aboard the *Granma,* and the 1961 repulsion of the U.S.–backed invasion at the Bay of Pigs *(Playa Girón).*

There are few examples of hero worship, unlike the countless portraits of Chairman Mao or Lenin typical of Chinese and Soviet posters. Only a handful of posters show Fidel Castro. By far the two most prominently featured individuals are José Martí and Ernesto "Che" Guevara. There are posters of well-known revolutionary heroes and martyrs, including Chile's Salvador Allende, Congo's Patrice Lumumba, South Africa's Nelson Mandela, and Vietnam's Ho Chi Minh. Some posters document lesser-known Cuban revolutionary martyrs, such as Frank País.[15] Figures from other countries honored in print include Black Panthers George Jackson and Angela Davis, Yasser Arafat, and even Sweden's Olaf Palme. Villains get their share, Nixon, Hitler, and Chile's Augusto Pinochet among them.

FORM

Although most of the posters are produced in offset format, many of them (including all the older ICAIC posters) were printed as silk screens in somewhat limited numbers.[16] Many of the more popular ICAIC posters have been reissued, often many times, to meet the demand for sales. Although the silk-screen print shop for ICAIC did not have the capacity to produce photographic stencils (all the posters, including those with a "halftone dot" appearance, were painstakingly cut by hand), the Editora Política offset shop certainly could—and did—produce full-color separations.

RENÉ MEDEROS
Vietnam Will Win
1971 Glad Day Press (Ithaca, N.Y.) 66 x 49 cm offset

EP's state sponsorship meant that it controlled the most modern production facilities, including a silk-screen press capable of printing billboard sheets and a large sheet-fed offset plant.[17] Interestingly, almost all Cuban posters are oriented in a vertical format. All of the ICAIC posters needed to be that way to fit into existing street kiosks, but the vertical uniformity of the others— only five of the OSPAAAL posters are oriented horizontally—appears to simply be a matter of convention.

INTERNATIONAL ARTISTIC RELATIONSHIPS

Despite the fervent wish on the part of the United States government for the "rogue state" of Cuba to be isolated from the world community, Cuban artists routinely engage in exhibits and work abroad. Europe, Canada, and Latin America all regularly include Cuban visual artists, musicians, and filmmakers in festivals, symposia, and shows. The U.S. embargo has served as an ominous, though penetrable, barrier for artistic exchanges between U.S. and Cuban nationals. Visas may be yanked at the last minute by the State Department, but institutions such as New York's Center for Cuban Studies and UCLA's art department continue to bring Cuban artists to this country in the spirit of cultural exchange.

Likewise, the efflorescence of graphic artwork flowing from Cuba has influenced and stimulated the work of poster artists in the United States. Any political poster maker with a pulse has at least a passing familiarity with some of the OSPAAAL posters. Many of the images have been formally or informally copied into U.S. posters. Some were reproduced for the Vietnam solidarity movement, such as René Mederos's graphic of Ho Chi Minh, printed in 1971 by Glad Day Press in Ithaca, New York.[18] The United States–based solidarity organization Venceremos Brigade has reissued many images for years as part of their campaign for ending the Cuban embargo. Other images have been appropriated for concerns such as Puerto Rican independence and the struggle against apartheid in South Africa. Several U.S. print shops have donated use of their facilities to print posters for Cuba—one of the OSPAAAL reprints proudly bears the union label of Berkeley's Inkworks Press, which produced the poster in a joint publishing project with Fireworks Graphics Collective.

Puerto Rico, acquired by the United States along with Cuba during the Spanish–American War, also developed strong artistic links with Cuba. The Graphics Workshop of the Institute of Puerto Rican

Culture, under the directorship of Lorenzo Homar, was a significant training ground for Puerto Rican artists and the source of an impressive body of work. These artists, like their Cuban counterparts, embraced the silk-screen process as a way to combine image, text, and a political message. It is no coincidence that at least one OSPAAAL poster was printed by sympathizers in Puerto Rico.

But more important, collaborative projects emerged when U.S. artists went to Cuba to teach and learn, and their Cuban counterparts were brought to the United States to share their experiences. Several progressive cultural institutions, including the Center for Cuban Studies in New York and Mission Grafica in San Francisco, sponsored shows and tours. The first California exhibit of Cuban posters was held in San Francisco's Palace of the Legion of Honor in 1975.[19] Two years later one of the organizers of that show, Juan Fuentes, visited Cuba to co-curate an exhibit by Bay Area Latino artists. Many U.S. artists acknowledge a deep debt to the creative spirit and political savvy that the Cuban poster movement engendered.

THE CURRENT SITUATION AND THE TASK AHEAD

I remember seeing my first Cuban poster on the wall of a student union in 1972. It was about solidarity with Vietnam, and I was impressed with its elegant and simple ability to convey the *concept* of solidarity. It showed individual strands, weak by themselves, woven together to resist modern weaponry. I was hooked. My first trip to Cuba as an adult was in 1989, when I went with a delegation of U.S. artists to the *Tercera Bienal de La Habana*, an international art exhibit held in Havana. The trip provided an opportunity for me to visit several Cuban graphic artists and poster-producing agencies. It quickly became apparent that there was far more depth to this body of work than I ever imagined. However, very little had been done to document and catalog it, let alone preserve it, and what little scholarship had been done on the topic was rich on anecdote but weak on data.

In 1970 McGraw-Hill published *The Art of Revolution*, with essays by author Susan Sontag and illustrator Dugald Stermer and color reproductions of postrevolutionary Cuban posters. No dedicated English-language book has appeared on the subject since, and few magazine articles have covered it. Only a handful of exhibits have been mounted. Most of them either focused on posters representing a specific theme (Che Guevara, the Vietnam War) or highlighted the work of

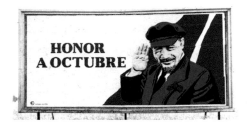

RENÉ MEDEROS
In Honor of October [Lenin]
circa 1989 billboard in Havana

a particular artist (Alfrédo Rostgaard).[20] In 1983 the Center for Cuban Studies in New York curated a groundbreaking exhibit at the Westbeth Gallery titled *Cuban Poster Art: A Retrospective, 1961–1982*, which featured posters by thirty-two artists. In 2001 the broad exhibit *¡Propaganda! Cuban Political & Film Posters 1960–1990* was hosted by the American Institute of Graphic Arts in New York and featured eighty posters. The show's highlight was participation by exile artist Félix Beltrán, and the exhibit was used primarily as a platform to discredit the Cuban government and decry the lack of artistic freedom under Castro.

Ever since the collapse of the Soviet Union and the Eastern Bloc in the early 1990s, Cuba has been laboring under what has been officially described as the "special period." Economically, the country went into a tailspin, losing favorable trade agreements, oil and sugar subsidies, and technical assistance almost overnight. Ever since, Cuba has followed a path of rebuilding its economy through international tourism. Massive joint-venture projects with Spain, Canada, Brazil, Mexico, and other nations have focused almost entirely on the hotel and ancillary service industries. This process, though justifiable given Cuba's limited economic options, has resulted in considerable distortion of the cultural fabric. All the poster-producing agencies have had to transform themselves from being state supported to relying on fee-for-service work. Although an organization such as ICAIC may have a chance at pulling this off, agencies with an explicit political message, such as EP or OSPAAAL, are withering on the vine. This belt tightening has affected Cuban art production in every way. What's more, because many supplies, such as ink, are in short supply, even aesthetic options are affected. One example is billboard design, which in the recent years has favored the use of white space.

Posters are a vital, expressive visual art form that has historically been a medium of choice for presenting oppositional voices. Unfortunately, the timeless issues that posters raise are usually eclipsed by their short public lifespan. First among the challenges to their preservation are physical conditions of deterioration stemming from poor ink and paper quality, staining and tearing as a result of poor display techniques, fading from exposure to sunlight, infestation by bugs and rot, damage from improper storage, and more. Then there are the posters lost entirely from the public record by succumbing to fire and water damage, ending up in the hands of private collectors, or simply being tossed in the trash. Cuba is no exception. As in the rest of the world, the very agencies that produced the posters had little energy or skilled staff devoted to preserving them.

Poster stacks at BNJM, 1999

In 1991 I joined Dan Walsh in forming the Cuba Poster Project. Walsh, the U.S.–based art director of Liberation Graphics, had successfully sued the U.S. Treasury Department for the right to travel to Cuba for the business of importing materials protected under the First Amendment, such as books and posters. Although the project ended several years later, it did provide an opportunity to learn of the fragile state of the various poster archives, and I subsequently continued my efforts to share these posters with the American public. In 1993 I visited the offices of Editora Política, and although the staff was able to produce a meticulously detailed catalog and slide sets of almost all the posters they had printed, they had very few of the actual posters on hand. Similarly, when I visited OSPAAAL and asked how many posters they had produced, they had no idea and guessed 150. It was only after returning to the United States and working with poster archivist Michael Rossman to survey collections here that we were able to eventually build the most complete catalog of these works to date. Some of the posters in the catalog have no known physical copy and exist only as 35mm slides. One is on record only because it was visible in a photograph of an exhibit in Havana. The surrogates that can be produced from digitized images have already proven their value. In 1998 OSPAAAL asked for display copies to use in an exhibit on Che Guevara. They did not have eight of the eighteen posters they had produced on Che, and I was able to send giant digital display prints from the new archive.

In the fall of 2000 I participated in making sure that the poster archives of Cuba's José Martí National Library (BNJM) were included in a historic exchange with the University of California at Berkeley. This project will eventually build a public-access collection of duplicate BNJM poster holdings in the United States. The BNJM will also receive assistance in preserving and cataloging its collection. Like many national repositories, the BNJM has played a valiant role in preserving Cuba's cultural heritage, but its resources are few and the task is large.

Because this ephemeral art represents an irreplaceable political and cultural heritage, I have been working with other poster archive activists—Michael Rossman and Carol Wells, of the Center for the Study of Political Graphics in Los Angeles—to develop a methodology for documenting and cataloging poster images and information to ensure that these works will remain potent voices of change. Our goal is to empower poster-producing organizations to preserve their own visual histories and allow them to breathe new life into images that were created many years ago. Because we are also concerned with preserving oppositional poster art in general, we see the documentation of "small" collections to be essential to the construction of a major archive of domestic and inter-

national posters. This approach is based on recent developments in database software and image digitization, which have only now become affordable to smaller collections. One wonderful feature of a digital catalog is that it is possible to build a comprehensive "collection" without possession of the actual artifacts, thus freeing poster-producing agencies from the separate and difficult tasks of collection and conservation. An image-rich database means that poster images can be quickly located and compared without reliance on curatorial memory or access to the actual poster.

Yet digital archives are only part of the solution. Print documents, such as this book, are essential to creating a permanent record and reaching a wide audience. Reproductions on a printed page, though smaller in scale than the originals, bring the viewer far closer to the sensory impact of the posters than any computer screen can. This book is a testament to the bridging of old and new technologies, just as the posters represented here reflect a bridging of old craft and new content.

★

★ CHAPTER ONE

NATIONAL PRIDE

ORGULLO NACIONAL

"Neither Nations nor Men Respect Anyone Who Fails to Make Himself Respected."

—José Martí, 1853–1895

Cuba has a complex colonial history, deeply affected by the slave trade and by the foreign powers that have interfered in its quest for self-determination—Spain, England, the United States, and to a lesser extent, the Soviet Union. This history strongly defines the Cuban national character and is essential to understanding Cuba's dogged efforts to be treated as an equal on the world stage.

By the time the Pope granted Cuba formal self-control in 1493, it was the unequaled hub of the Spanish empire in the Americas. Indigenous people were forced into serfdom, inspiring the first revolt in the New World, under Taino chief Hatuey (burned at the stake in 1512). The Tainos perished from overwork and disease and were replaced by African slaves as early as 1513. Spain levied heavy taxes and forced unfair trade agreements on Cuba, and the first in a long series of citizen rebellions against the Spanish crown broke out in 1740. England occupied Cuba in 1762 but traded it back for Florida the following year. As in other colonial countries, the local population—Cuban-born "criollos"—developed an interest in self-determination and was inspired by the success of the American Revolution. From the earliest days of the republic, however, the United States government and business leaders seemed more interested in owning Cuba than seeing it free.

> *"I candidly confess that I have ever looked upon Cuba as the most interesting addition that can be made to our system of States, the possession of which would give us control over the Gulf of Mexico and the countries and isthmus bordering it."*
>
> *—Thomas Jefferson, 1809*[21]

Cuba was rocked by its First War of Independence (1868–1878), led by General Máximo Gómez (a white criollo) and Antonio Macéo (a mulatto). It resulted in 250,000 Cuban and 80,000 Spanish casualties. The revolt failed, however, and left the island's economy in shambles. The poet and author José Martí, imprisoned and deported during that war, used his stay in New York to found the Cuban Revolutionary Party on the mutual principles of nationalism and social justice. In 1895 he joined up with fellow exiles Gómez and Macéo for another revolution. Although Martí was killed almost immediately, and Macéo was killed the following year, the Second War of Independence continued to wrack the country until the fateful evening of February 15, 1898, when the U.S. battleship *Maine* exploded in Havana harbor, killing 260 men. Although a board of American naval officers determined that a submarine mine caused the ship's forward magazine to explode, no specific persons or parties were implicated.

A variety of political and economic forces had put the United States on a collision course with Spain over Cuba and its only other remaining colony in the Americas, Puerto Rico. Trade between Cuba and the United States had grown steadily since the American colonial period, and American citizens eventually came to own millions of dollars worth of Cuban property, primarily in the sugar, tobacco, and iron industries, all of which were imperiled by the fighting. These conditions—economic self-interest, coupled with expansionist interests in the hemisphere and public outrage over accounts of Spanish military brutality against the Cubans and U.S. citizens—created a powder keg, and the *Maine* was the fuse. On April 19, 1898, the United States Congress passed a joint resolution proclaiming Cuba "free and independent," and

when signed by President McKinley the next day, it served as a declaration of war.

> *"War with Spain would increase the business and earnings of every American railroad, it would increase the output of every American factory, it would stimulate every branch of industry and domestic commerce."*
> —*John Mellon Thurston, U.S. Senator from Nebraska 1895–1898*[22]

The war was immensely popular in the United States and was over in less than a year. In the end, U.S. goals were overwhelmingly achieved, but at the expense of Cuban aspirations. The Cuban war for independence had been hijacked to become the "Spanish-American War." Cuban forces were not allowed to attend the surrender ceremonies, nor were Cuban representatives invited to the signing of the peace treaty in Paris. The U.S. army of occupation demobilized the Cuban army and appointed Spanish officers to security positions. In 1902 the Cubans accepted the Platt Amendment, which gave the United States the unconditional right to intervene in Cuba's internal affairs and perpetual rights to the coaling station at Guantánamo Bay as the only alternative to direct U.S. military rule. A cycle of dependence on U.S. approval had begun, only to be broken by the success of the revolution against Batista in 1959.

It was against this backdrop that the new revolutionary government struggled to establish itself. Like Martí before him, Fidel Castro was a nationalist and an anti-imperialist, and the United States government grew increasingly uncomfortable as a series of popular measures—starting with the Agrarian

Reform Law during Castro's first year in power—made it clear that he had no wish to follow U.S. policy. Relations between the two countries continued to unravel. When Soviet crude oil arrived in Havana, American-owned refineries refused to process it, and they were nationalized. When the United States refused to buy Cuban sugar (and the Soviet Union did not) American-owned sugar mills were nationalized. Eventually this downward spiral led to an effort by exiled Cuban nationals to retake the country in the failed Bay of Pigs invasion in 1961. This escalation of hostilities led to the Cuban Missile Crisis the next year. Although formal invasion efforts ceased, covert operations against Fidel and the Cuban economy continued for many years. The U.S. government has also pursued an official economic blockade of the island that has significantly hurt Cuba's effort to become self-sufficient. Aid from and trade with other countries have to a large extent mitigated the impact of the U.S. embargo, but it unquestionably has reinforced the United States government's appearance to the Cuban people (and much of the rest of the world) as a bully.[23] This, in turn, has fueled Cuban nationalism, and the cycle shows no sign of ending.

★

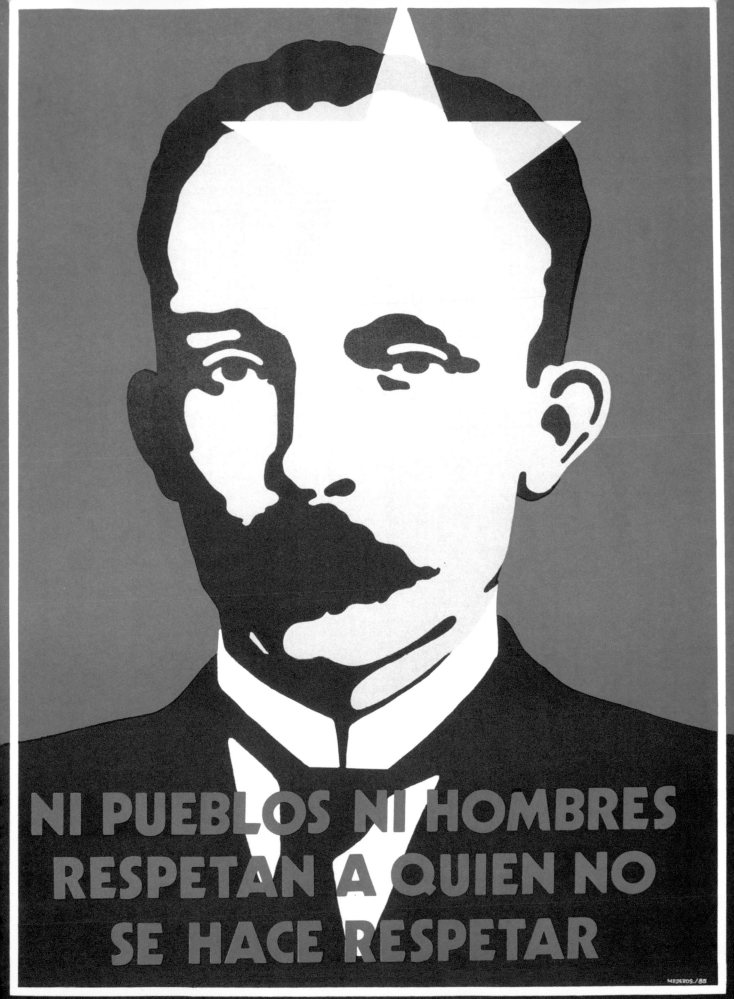

NI PUEBLOS NI HOMBRES
RESPETAN A QUIEN NO
SE HACE RESPETAR

ROBERTO FIGUEREDO
The Bravest, the Most Productive, the Most
Extraordinary of Our Fighters—Fidel Castro
1977 EP (DOR) 59 x 39 cm silk screen

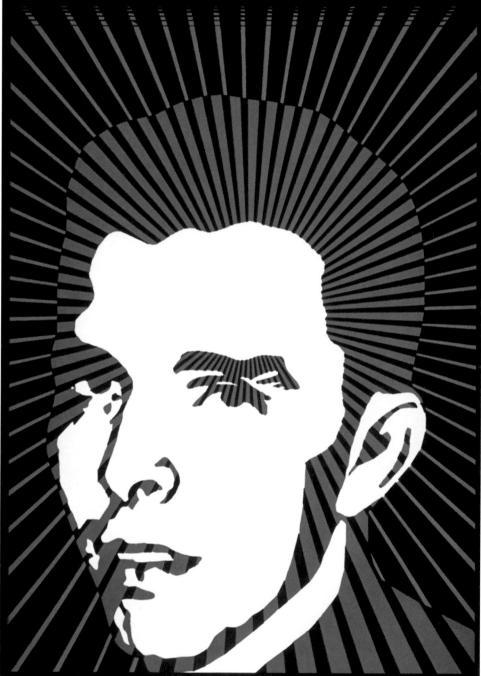

FAUSTINO PÉREZ
30th Anniversary of the Moncada
1983 EP (DOR) 75 x 50 cm offset

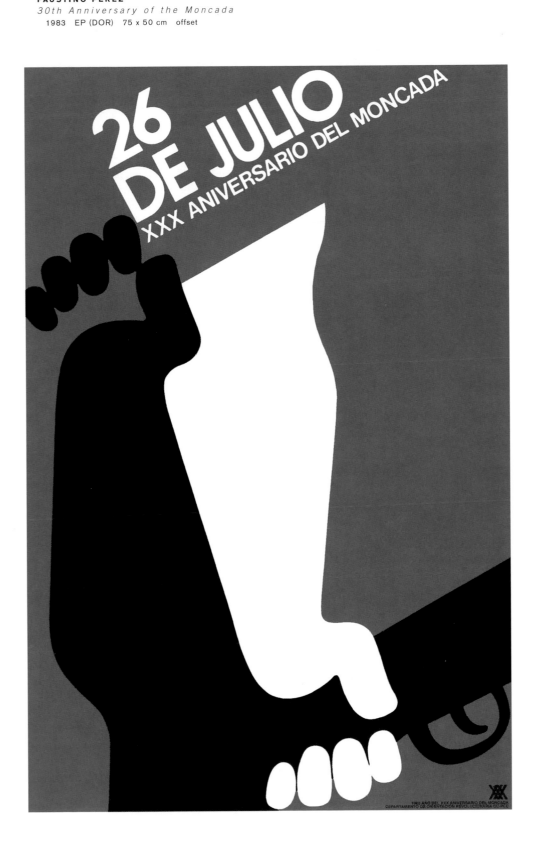

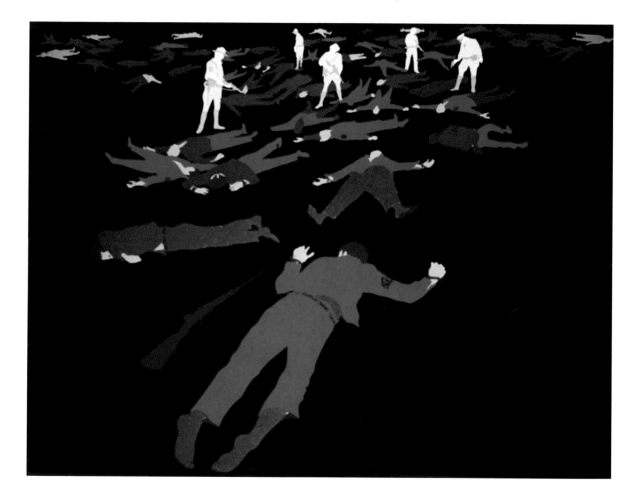

RENÉ MEDEROS
The Martyrs
1973 EP 41 x 61 cm silk screen
#19 in Moncada series

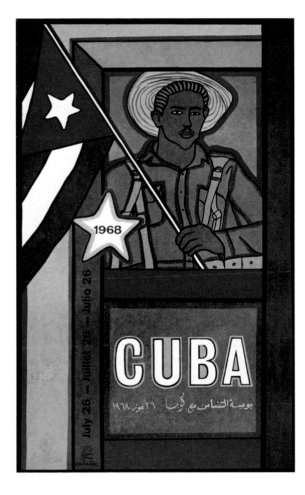

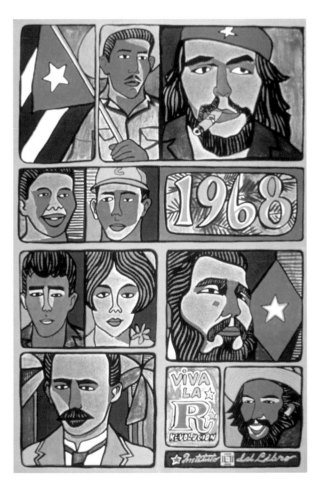

RAUL MARTÍNEZ
Cuba / 1968
1968 OSPAAAL 54 x 33 cm offset

RAUL MARTÍNEZ
Long Live the Revolution / 1968
1968 EP (for ICL) 49 x 34 cm offset

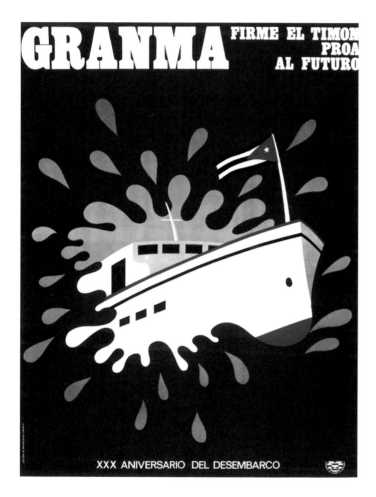

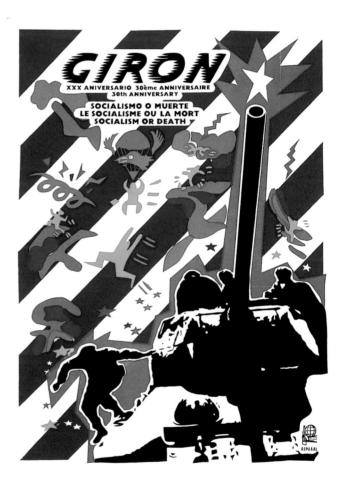

FAUSTINO PÉREZ
Granma / Following a Firm
Course, Bow to the Future
1986 EP (for EPG) 51 x 38 cm offset

ELADIO RIVADULLA PÉREZ
Giron / 30th Anniversary /
Socialism or Death
1991 OSPAAAL 70 x 51 cm silk screen

JUAN ANTONIO GÓMEZ
To Act Is the Best Way to Make a Point
1983 EP (DOR) 78 x 48 cm silk screen

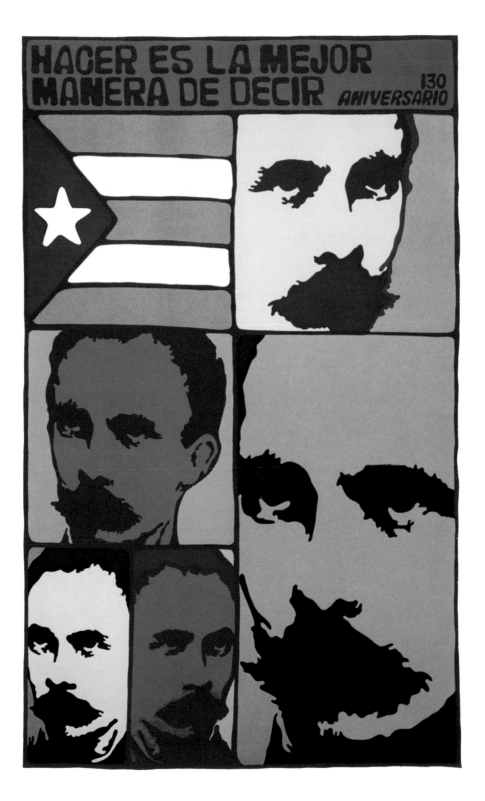

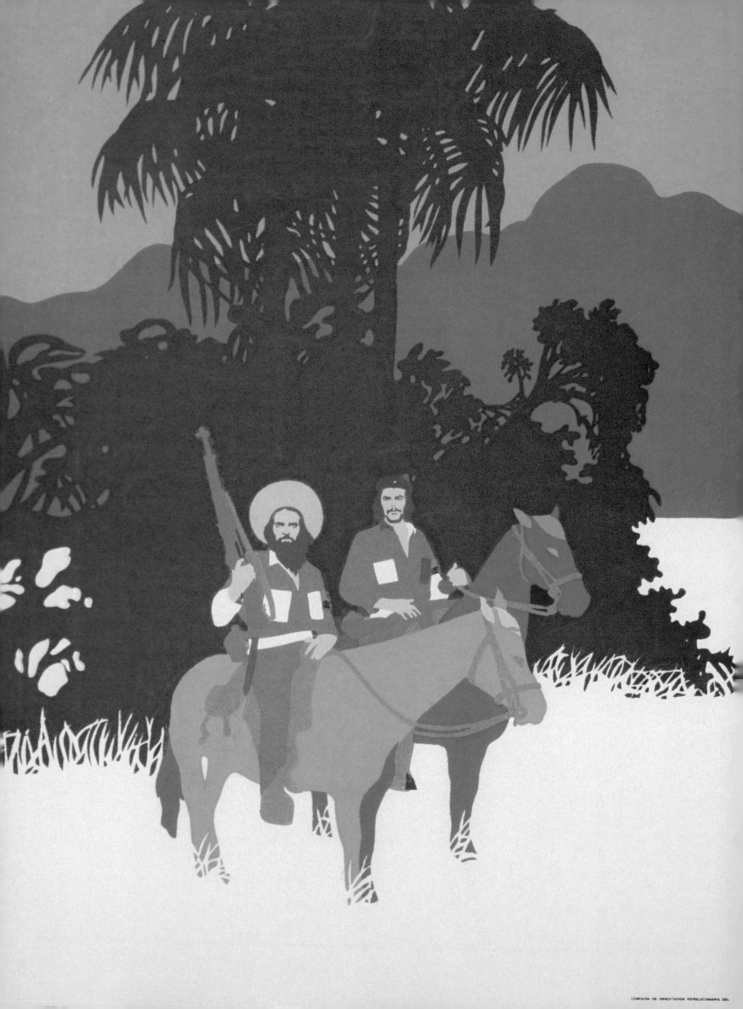

RENÉ MEDEROS
1959–1969 Tenth Anniversary of the Triumph of the Cuban Revolution
1969 EP (COR) 79 x 50 cm offset

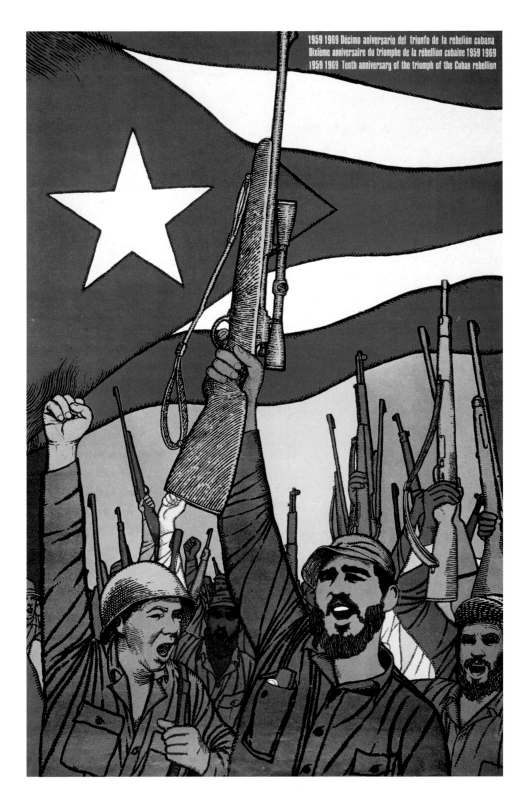

1959 1969 Décimo aniversario del triunfo de la rebelión cubana
Dixième anniversaire du triomphe de la rébellion cubaine 1959 1969
1959 1969 Tenth anniversary of the triumph of the Cuban rebellion

Left

RENÉ MEDEROS
(no title) Camilo and Che
1972 EP (COR) 73 x 58 cm silk screen

RAFAEL MORANTE
Cuba and Martí Present at the Moncada
1983 OSPAAAL 66 x 39 cm offset

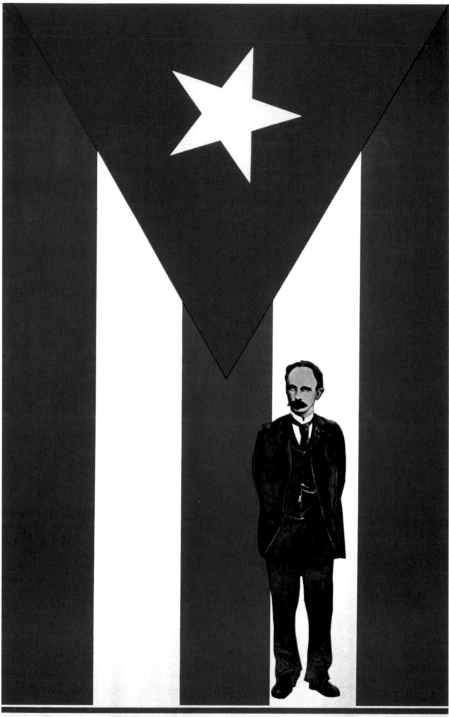

FÉLIX BELTRÁN
We deeply admire Martí for his gigantic task, forming a revolutionary
consciousness in our nation's mind (quote from Fidel Castro)
1976 EP (for BNJM) 52 x 33 cm offset

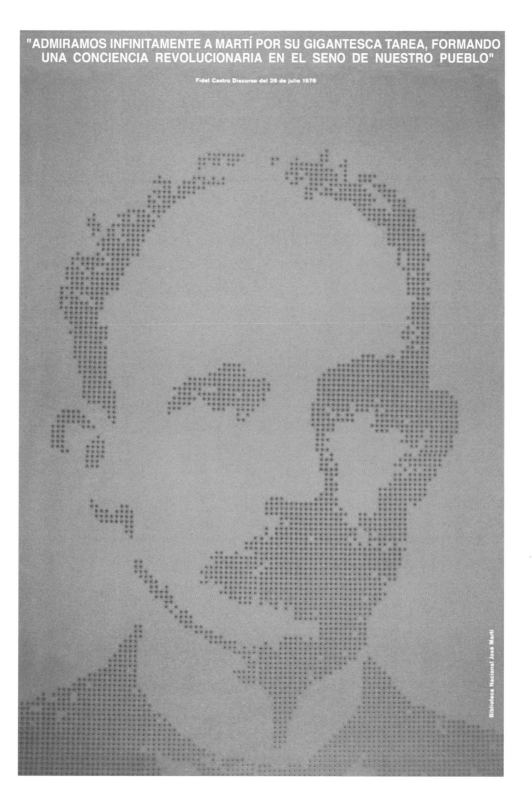

PRODUCTION AND RESOURCES

PRODUCCIÓN Y RECURSOS

"The Tobacco Harvest Awaits Your Youthful Hand"

—poster for DOR, 1983

Approximately one-quarter of the Cuban workforce is employed in agriculture, one-quarter in industry, and the remaining half in the services sector.[24] Exports go principally to Russia and the Netherlands (23 percent each), followed by Canada (13 percent) and other countries, and the top imports come from Spain (18 percent), Venezuela (13 percent), and Canada (8 percent).[25] Ever since its founding, Cuba's entire economy has relied on the cultivation and export of just two crops: sugar and tobacco. This is due to the influence and needs of foreign interests, and the resulting distortion of an export monoculture has driven Cuba's economy for hundreds of years. Promoting agriculture remains a major emphasis of domestic campaigns, many of them equating the struggle for economic self-sufficiency with the military sacrifice of the revolution, as exemplified by the 1971 poster *To Camagüey —With the Faith and Valor of the Fighters at the Moncada.* Similarly, the phrase "as in Vietnam" is used as an exhortation to emulate the tenacity, organization, and discipline of the Vietnamese people.

Cuba's soil chemistry and climate are perfect for the cultivation of cane sugar, and about 75 percent of the agricultural export income is drawn from this single crop. A national volunteer campaign to realize a ten-million-ton sugar harvest by 1970 fell short of its goals, but the *zafra*—the sugar harvest— and the ancillary activities of operating and maintaining the mills remain significant activities. Posters promote the *Sugar Harvest '85—at Full Capacity,* encourage workers to *Pull Together with Efficiency and Quality,* to *Cut until the Last Cane,* and to *Clear the Way for Sugar from the Mill!* When it is all over, we are told, the *Harvest Quota [is] Achieved.* The growing and processing of tobacco is also an essential part of the culture—posters announce, *The Tobacco Harvest Awaits*

Your Youthful Hand and rejoice in *Happiness in the Tobacco Fields.* Other crops are encouraged as well: *The Land Is Fertile—Work for the Whole Population [to] Plant Every Field.*

As an island nation, Cuba is particularly dependent on imported goods. Because of the U.S. blockade and a shortage of natural resources, many public campaigns have been advanced on such issues as reducing electrical waste, saving fresh water, and recycling glass.

Following pages (left)
HUMBERTO TRUJILLO
Only That Which Is Necessary
1981 EP (DOR) 56 x 40 cm offset

Following pages (right)
JUAN A. GÓMEZ
*The Tobacco Harvest Awaits Your
Youthful Hand*
1983 EP (DOR) 74 x 48 cm silk screen

SOLO
LA NECESARIA

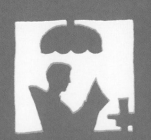

EL TABACO ESPERA
TU MANO JOVEN

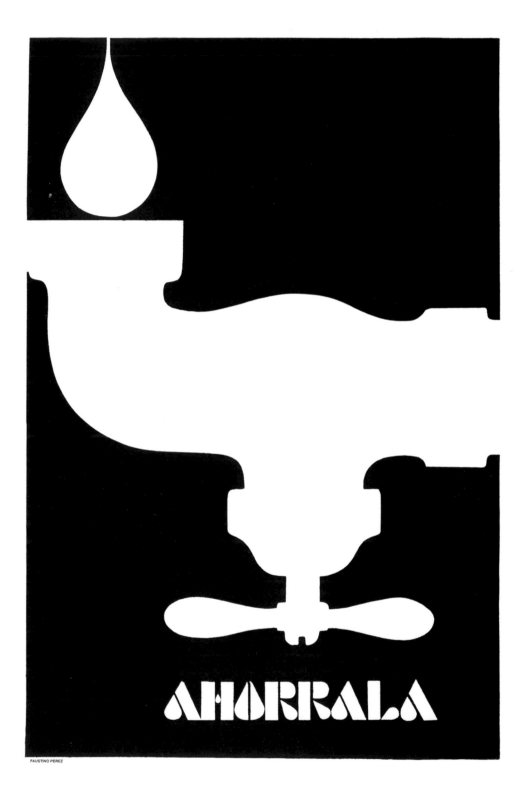

JUAN A. GÓMEZ
Sugar Harvest '85
1984 EP (DOR) 76 x 51 cm silk screen

HERIBERTO ECHEVERRÍA
March 8—
International Women's Day
1971 EP (COR) 76 x 36 cm offset

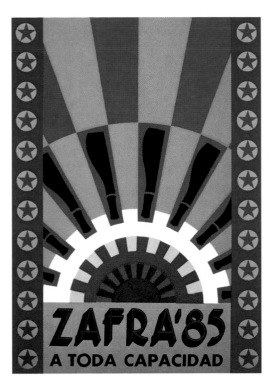

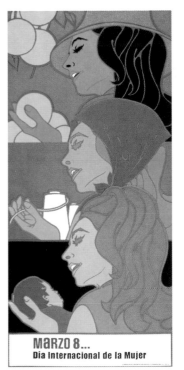

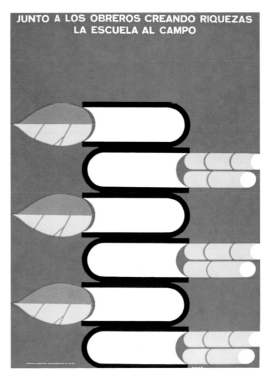

ESTELA DÍAZ
Alongside the Workers
Harvesting Wealth—
The Farm School
1972 EP (COR) 65 x 47 cm silk screen

DAYSI GARCÍA
To Celebrate the Ten Million—
Add to the Happiness with
Your Empty Bottles
1970 EP (COR) 75 x 43 cm offset

JOSÉ PAPIOL
Clear the Way for Sugar from the Mill!
1972 EP (COR) 71 x 44 cm offset

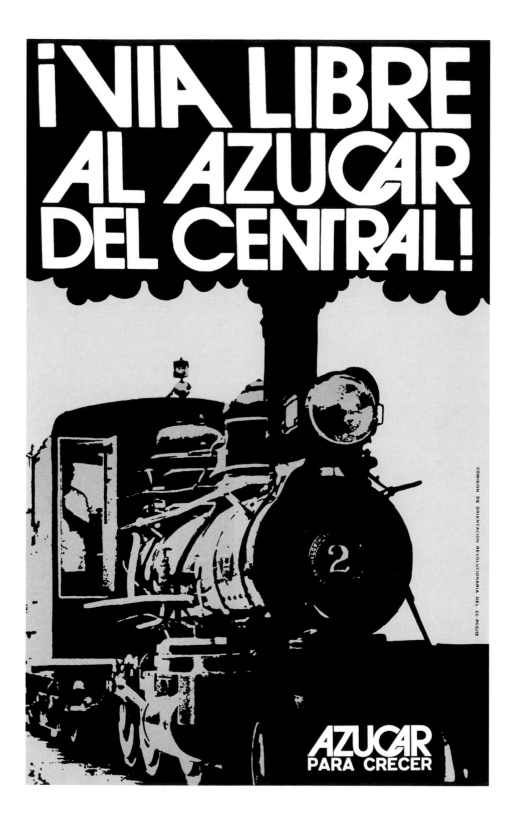

JUAN ANTONIO GÓMEZ
Pull Together with Efficiency and Quality
1975 EP (DOR) 70 x 46 cm offset

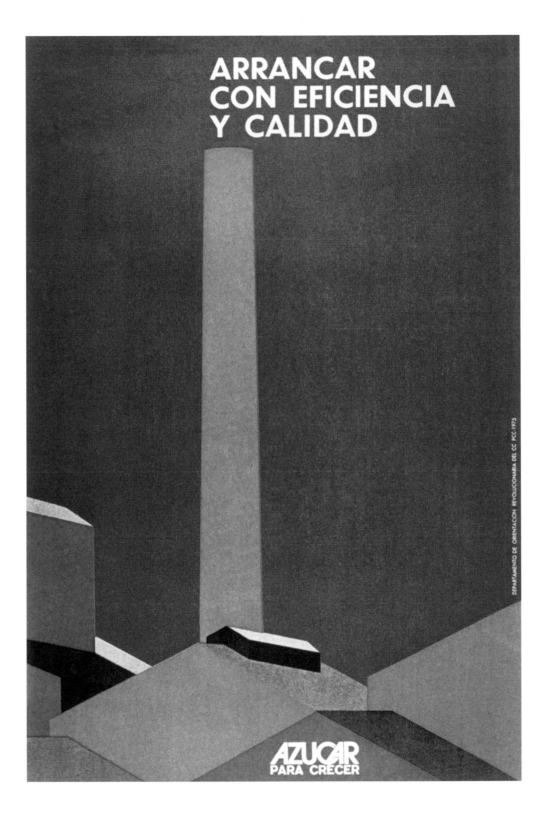

GLADYS ACOSTA
Cut Until the Last Cane
1971 EP (COR) 59 x 39 cm offset

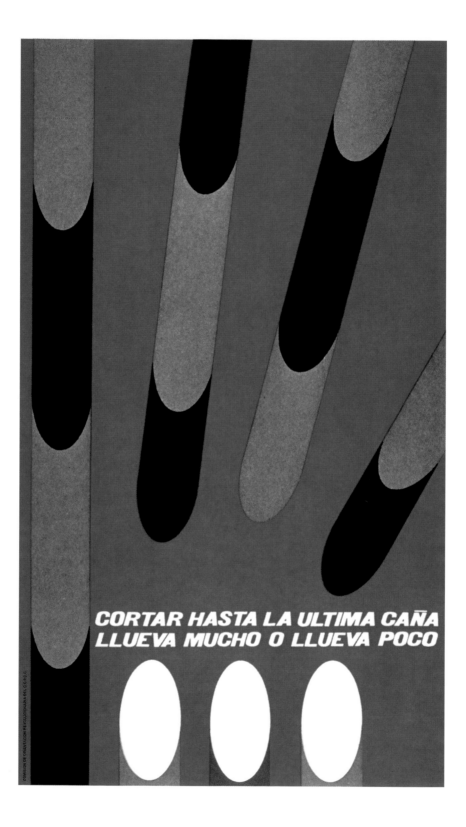

RENÉ MEDEROS
*To Camagüey—With the Faith and Valor of
the Attackers of the Moncada*
1971(?) EP (for UJC) 71 x 46 cm offset

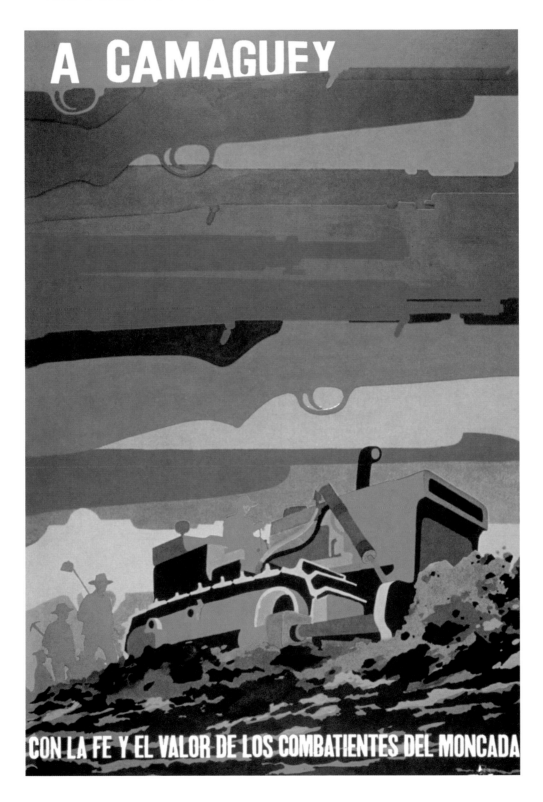

HERIBERTO ECHEVERRÍA
Harvest Quota Achieved (sugar)
1972 EP (COR) 76 x 38 cm offset

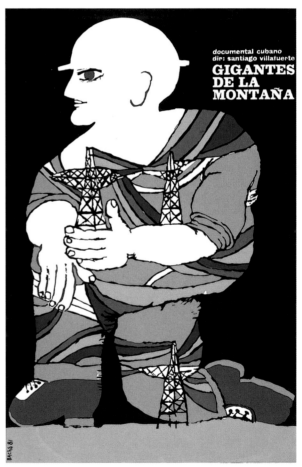

EDUARDO MUÑOZ BACHS
Giants of the Mountain
1981 ICAIC 76 x 51 cm silk screen

JUAN ANTONIO GÓMEZ
Happiness in the Tobacco Fields /
1984–85 Harvest
1984 EP (DOR) 77 x 52 cm silk screen

CHAPTER THREE

SPORTS AND HEALTH
DEPORTE Y SALUD

"I would rather play for ten million people than ten million dollars."

*—Cuban baseball pitcher Omar Linares, answering reporters' questions about why
he didn't wish to defect to the United States at the 1996 Olympics in Atlanta, Georgia*

Cuba has produced many great athletes and teams. Its boxers have earned twenty-three Olympic gold medals (Teofilo Stevenson alone took three heavyweight gold medals), eighty-seven senior and junior world titles, and twenty-five world cups. Cuba has excelled in other Olympic sports as well, including swimming, judo, fencing, volleyball, and track (Alberto Juantoreno won gold medals in the four-hundred and eight-hundred-meter runs at the 1976 Olympics in Montreal, Canada). Sports, as part of physical culture in general, are considered to be an integral component of a well-rounded and healthy populace. In many Western countries massive private advertising budgets are spent encouraging people to buy a particular athletic shoe or paying for naming rights to sports facilities. Teams and players are bought and sold as commodities. The commercialization of physical activity is so pervasive that it is taken for granted. Yet in Cuba, posters advertise sporting events, rather than individual teams, and encourage whole communities to participate in sports for the simple reason that it is good for them. This public campaign is captured in the sweet, simple message, "To practice sports is to grow healthy."

A commitment to public well-being is also at the heart of health care policy in Cuba. As one would expect of a state agency responsible for educating the citizenry about issues of public health, EP's posters cover a wide range of issues, including encouraging people to plant fruits and vegetables, work carefully when trimming meats, and quit smoking. Other posters publicize important public services such as the motorized health brigades that serve the rural population.

★

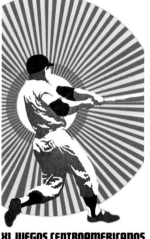

**XI JUEGOS CENTROAMERICANOS
DEL CARIBE PANAMA FEBRERO 1970**

JESÚS FORJÁNS
11th Games of Central America and the Caribbean
1970 EP 70 x 39 cm offset

LUIS ALVAREZ
Cuba Motorcycle Cup
1972 EP (COR, for INDER) 71 x 47 cm silk screen

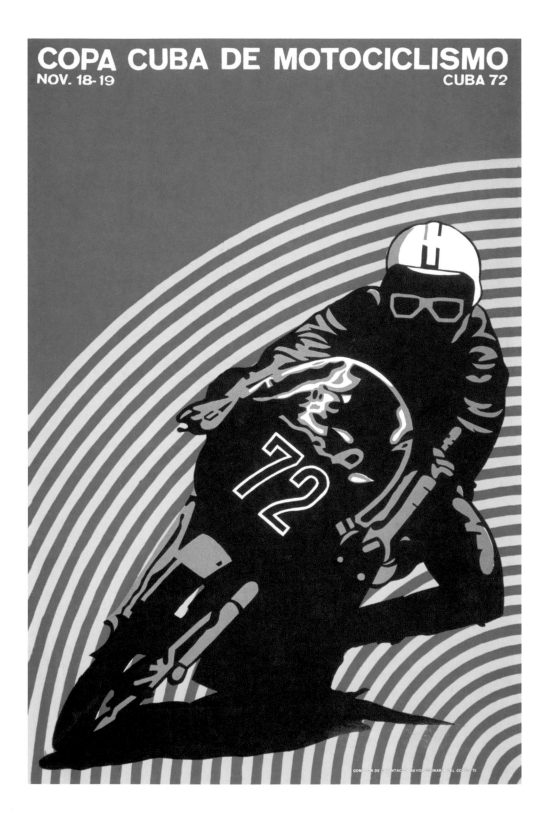

HERIBERTO ECHEVERRÍA
9th Hemingway (Deep Sea Fishing)
Competition
1971 EP (for INDER) 76 x 36 cm silk screen

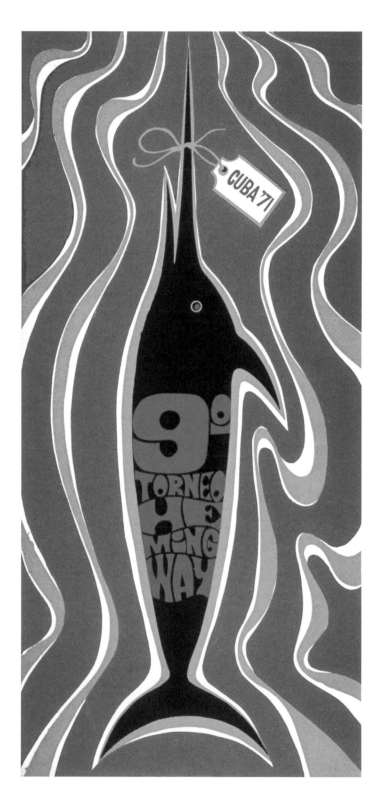

ARTIST UNKNOWN
Juantorena
 (1970s) ICAIC 76 x 51 cm silk screen

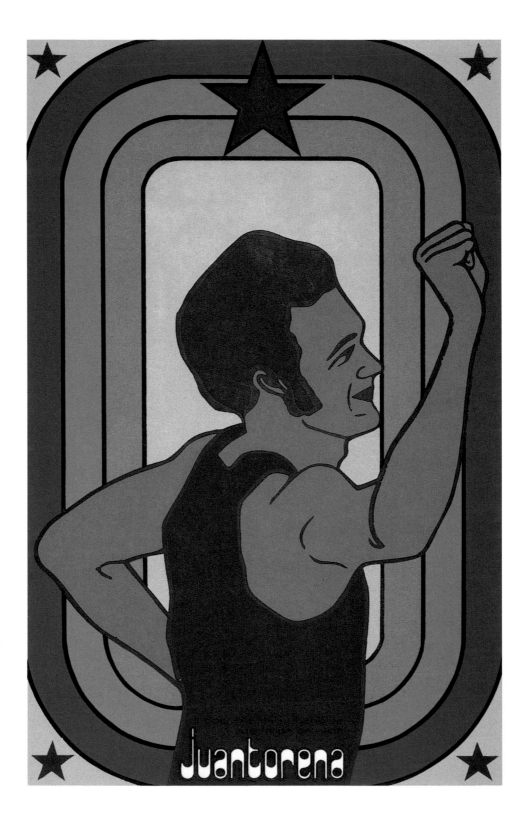

JOSE LAMAS
11th National Amateur Baseball Series
 1972 EP (for INDER) 73x46 silk screen

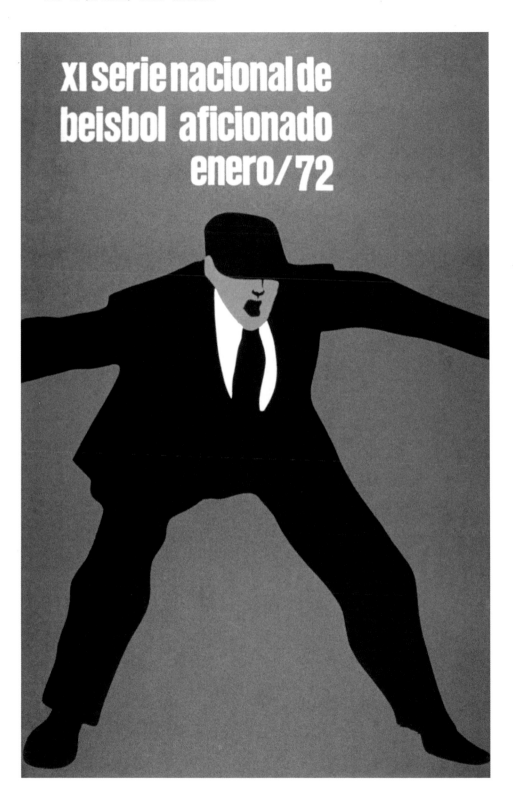

DAYSI GARCÍA
Working for the Ten Million (Motorized Health Brigade)
1970 EP (COR) 73 x 54 cm silk screen

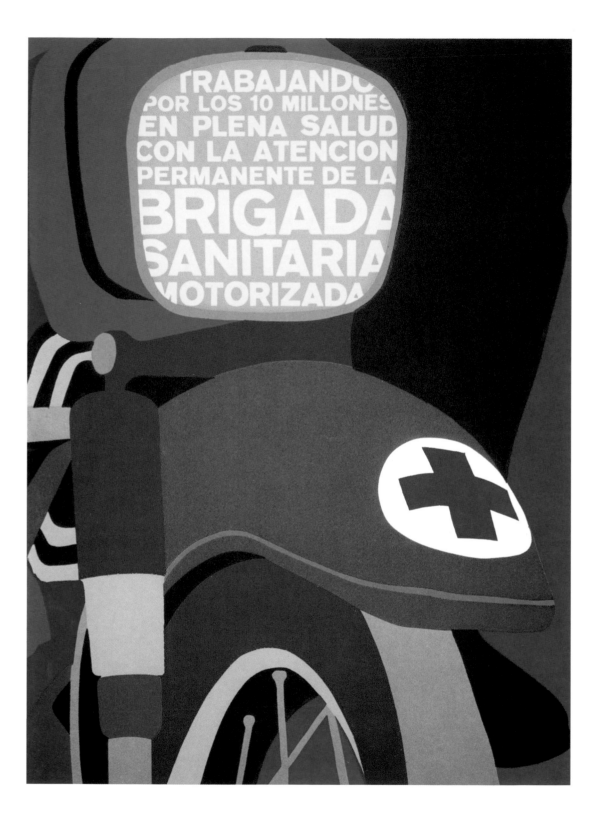

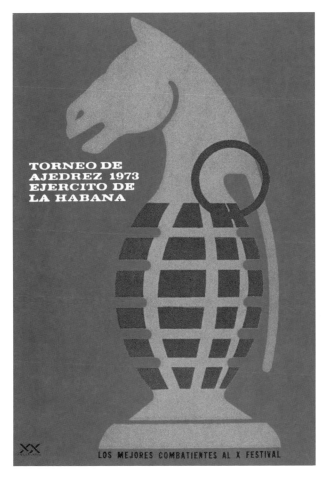

ISRAEL FUNDORA
Army Chess Tournament
1973 EP 66 x 44 cm silk screen

JOSÉ PAPIOL
6th Bicycle Tour of Socialist Cuba
1969 EP (for INDER) 65 x 39 cm silk screen

PRACTICAR DEPORTES ES CULTIVAR LA SALUD

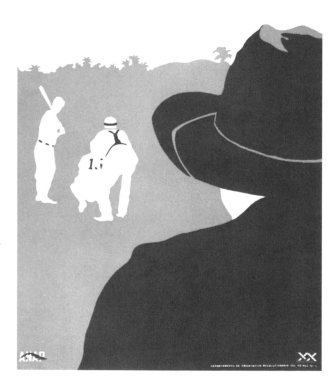

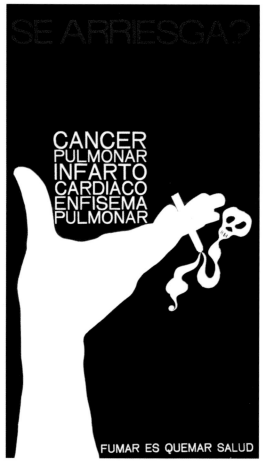

EDUARDO MURÍN PORTRILLÉ
To Practice Sports Is to Grow Healthy
1973 EP (DOR) 52 x 34 cm offset

ERNESTO PADRÓN
Smoking Burns Your Health
1970 EP (for MINSAP) 68 x 21 cm offset

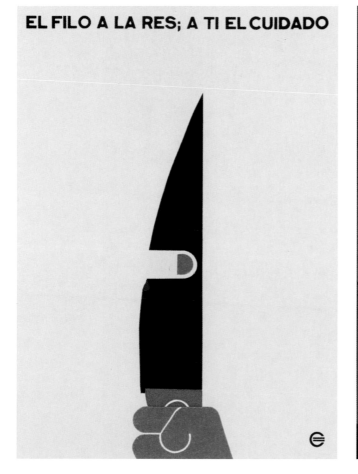

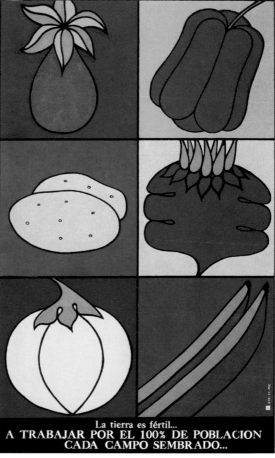

FAUSTINO PÉREZ
Knife to the Beef—Be Careful!
1971 EP (COR) 55 x 40 cm silk screen

JUAN ANTONIO GÓMEZ
The Land Is Fertile
1983 EP (for EPG) 78 x 49 cm silk screen

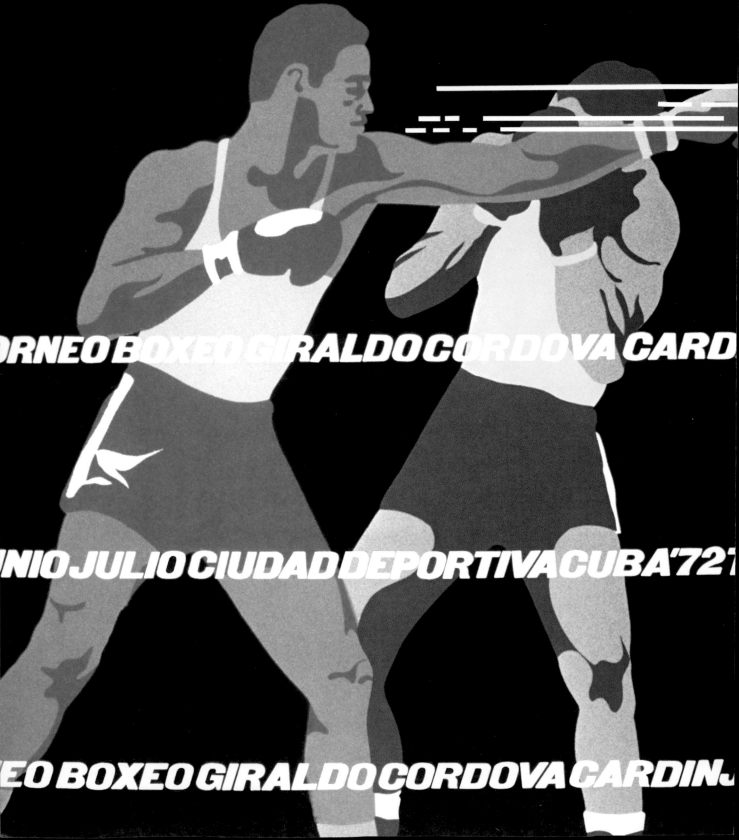

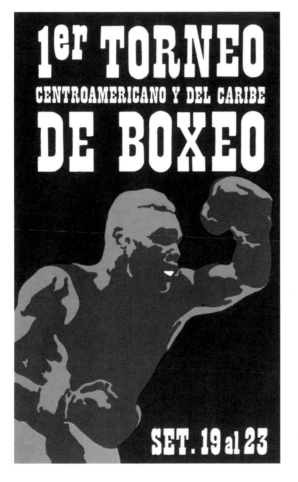

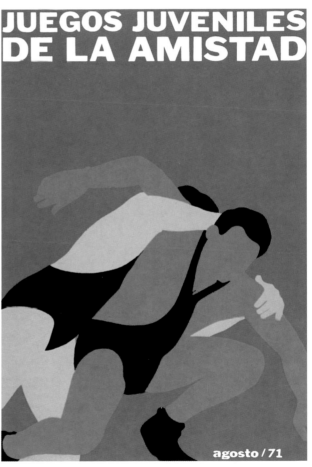

★ CHAPTER FOUR
SOLIDARITY AND REVOLUTION
SOLIDARIDAD Y REVOLUCIÓN

"Solidarity is not charity, but mutual aid in pursuit of shared objectives."

—*Samora Machel, FRELIMO (Frente de Libertaçao de Mozambique) revolutionary hero and first president of Mozambique* [26]

Ever since Fidel Castro's troops successfully defeated the Batista regime in 1959, Cuba has actively supported movements for fundamental political change all over the world. This includes support of struggles for national liberation—the process that many countries endured to emerge from colonial control during the 1960s and 1970s—and of revolutionary organizations within certain countries that have resorted to armed struggle to overthrow unpopular regimes. Most of these countries constitute what is known as the "third world." They have suffered underdevelopment as a consequence of modern colonial status or have experienced dramatic social inequality as a result of corrupt foreign-supported governments, and they are generally located in the continents of Africa, Asia, and Latin America.

Solidarity is a political term that can mean many things. It can range from formal support, with military troops and materiel (such as Cuba sent to guerrillas in the Congo), to more benign activities such as sending food or skilled personnel to other countries. It also means public support of these countries and their issues, with United Nations speeches and posters distributed worldwide. Some of these posters take on abstract political issues, such as foreign debt, liberation theology, armed struggle, the influence of the International Monetary Fund, and even capitalism itself. However, most solidarity posters focus on specific events and issues.

The primary enemy of subjects in colonial countries was usually the military and police forces of the occupying Europeans. However, national liberation struggles also served as a theater for the grander geopolitical battle being waged between United States and its archenemies, the Soviet Union and China. Thus, by engaging in support for the oppositional forces, Cuba became a significant participant in the larger struggle between capitalism and socialism. In many cases, public U.S. foreign policy only hinted at the actual role the United States played in supporting the colonial powers, and the implementation of more clandestine foreign policy goals fell to the Central Intelligence Agency, special operations units of the armed forces, and surrogate mercenaries. Many of the affected countries are ones that most Americans are only vaguely aware of—the Congo, Zimbabwe, Guinea-Bissau—but others such as Vietnam and South Africa are better known.

Cuba deeply identified with Vietnam, a small, poor country attempting to overthrow a series of corrupt leaders serving the interests of a chain of foreign masters. Cuba was one of the earliest and most persistent supporters of Nelson Mandela and the African National Congress at the same time that the United States government avoided taking a stand. In some cases, Cuban solidarity has included geopolitical entities that were not even countries. Puerto Rico is seen as a colonial vestige of more than a hundred years of U.S. occupation, and Palestine is respected as a nation without a state.

Cuban solidarity posters have honored martyrs (Sandino in Nicaragua), chastised U.S. intervention (the Dominican Republic), endorsed domestic opposition within the United States (as carried out by the Black Panther Party), or noted the struggle of whole countries (Guatemala), populations (the Arab people), and generic exploited classes (peasants in Peru). Many posters have supported the struggle of Cuban allies that U.S. foreign policy has simply labeled unacceptable. The democratically elected governments of these countries were seen as a threat

ELENA SERRANO
Day of The Heroic Guerrilla (Continental Che)
1968 OSPAAAL 50 x 33 cm silk screen and offset

to U.S. business and political interests, and overt military invasions (Grenada) or covert CIA actions (Chile) resulted in their replacement by more acceptable leadership.

Finally, there is the theme of Che and exporting revolution. Ernesto "Che" Guevara was an asthmatic Argentinian doctor who met Fidel Castro in 1954, participated in the Cuban revolution, served as head of various government agencies, and never gave up his dream of world revolution. He participated in clandestine guerrilla activities in the Congo and in Bolivia, where he was finally caught and executed in 1967. He has attained mythic status for some as a hero of the oppressed, is criticized by some for adventurism and vanguardism, and is demonized by others as a murderous Marxist-Leninist. His image is by far the best-known symbol of revolution in the world. Public and private display of his portrait in Cuba is ubiquitous.

★

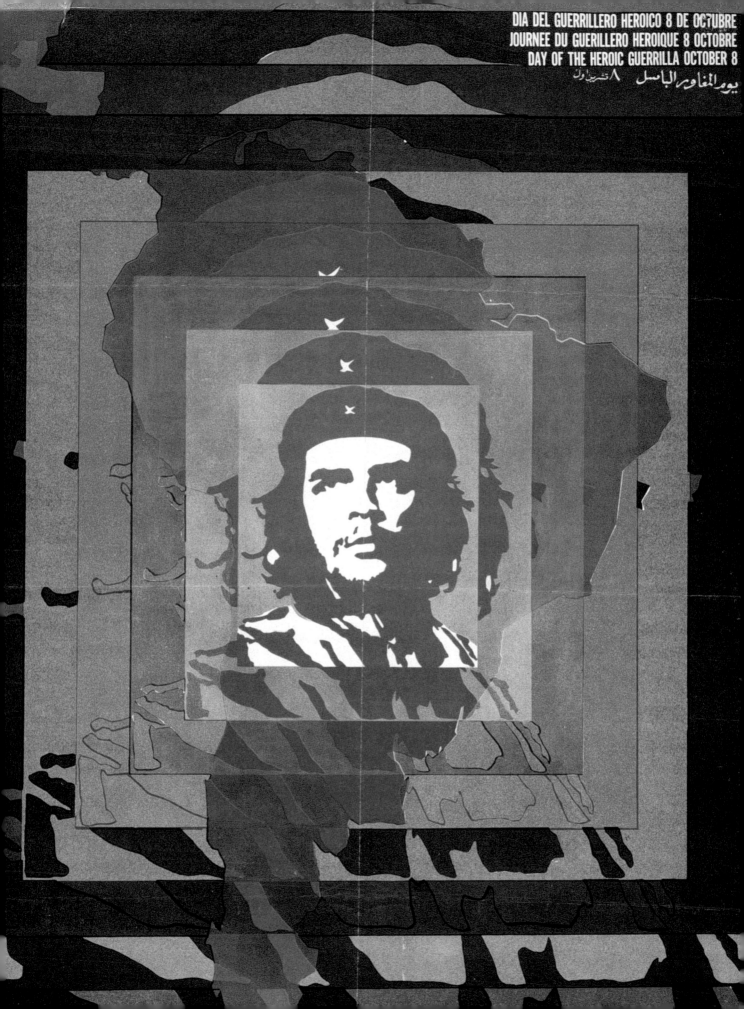

ASELA PÉREZ
International Week of Solidarity with Latin America
1970 OSPAAAL 53 x 33 cm silk screen

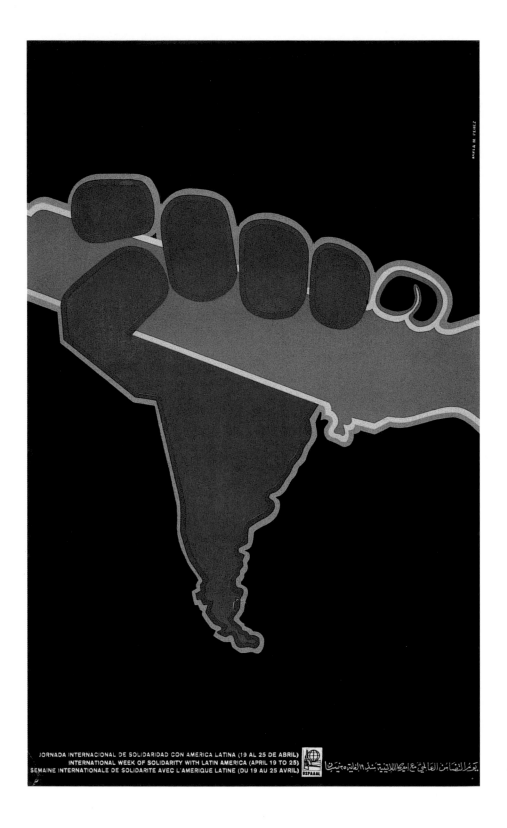

ALFRÉDO ROSTGAARD
Day of Solidarity with the Congo (L)
1972 OSPAAAL 53 x 33 cm offset (Patrice Lumumba)

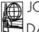 JORNADA DE SOLIDARIDAD CON EL CONGO (L) 13 DE FEBRERO
DAY OF SOLIDARITY WITH THE CONGO (L) 13 FEVRIER
JOURNEE DE SOLIDARITE AVEC LE CONGO (L) FEBRUARY 13

يوم التضامن مع الكونغو ليوبولدفيل ١٣: اشباط

OLIVIO MARTINEZ
*International Campaign of Solidarity
with the People of Korea*
1973 OSPAAAL 68 x 46 cm offset

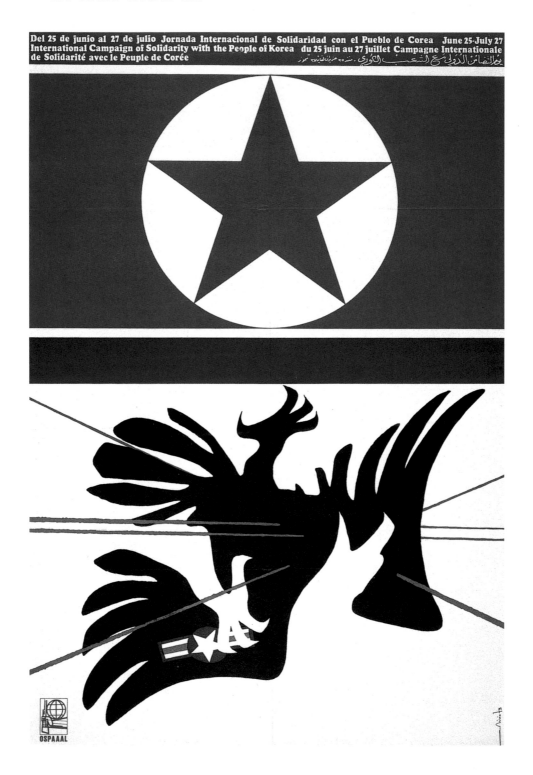

ALFRÉDO ROSTGAARD
(no title) Guerrilla Christ
1969 OSPAAAL 60 x 42 cm offset

(Homage to Camilo Torres, revolutionary Colombian
priest killed in combat in 1966)

RAFAEL ENRÍQUEZ
Foreign Debt / IMF
(International Monetary Fund)
1983 OSPAAAL 68 x 49 cm offset

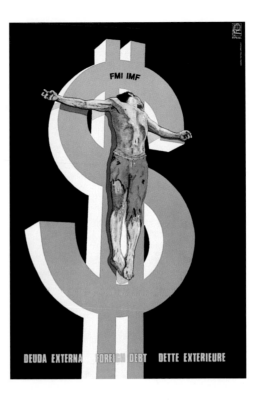

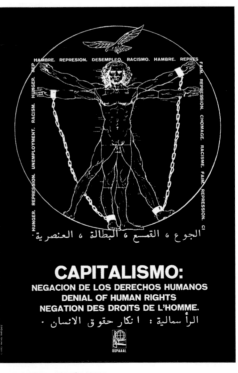

RENÉ MEDEROS
(no title) Nixon Tearing the
Heart out of Indochina
1971 OSPAAAL 53 x 33 cm offset

RAFAEL ENRÍQUEZ
Capitalism—Denial of Human Rights
1977 OSPAAAL 50 x 38 cm silk screen

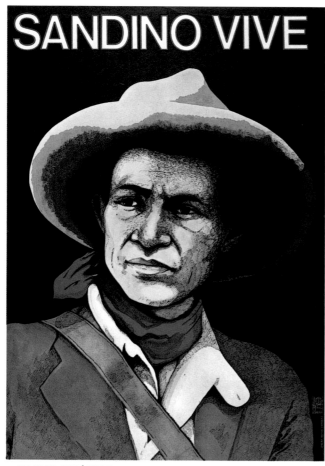

RAFAEL ENRÍQUEZ
Sandino Lives
1984 OSPAAAL 69 x 48 cm offset

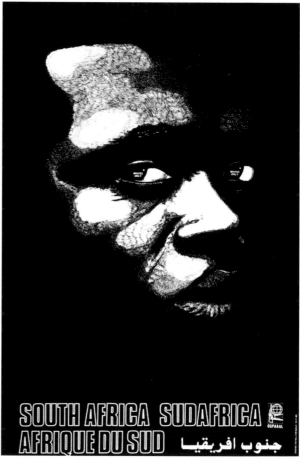

RAFAEL ENRÍQUEZ
South Africa / Whites Only
1983 OSPAAAL 73 x 48 cm offset

ALBERTO BLANCO
For a Vietnam Ten Times More Beautiful
1980 OSPAAAL 71 x 47 cm offset

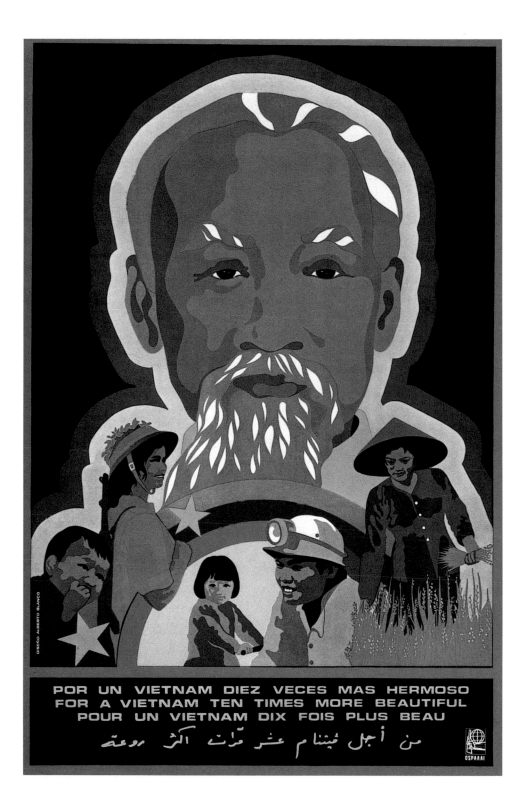

OLIVIO MARTINEZ
Solidarity
 1972 OSPAAAL 54 x 33 cm offset

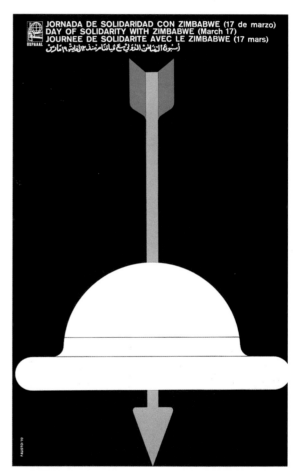

FAUSTINO PÉREZ
Day of Solidarity with Zimbabwe
1970 OSPAAAL 54 x 33 cm offset

BERTA ABELENDA
Day of Solidarity with the People of South Africa / June 26
1968 OSPAAAL 54 x 33 cm offset (colorized African National Congress logo)

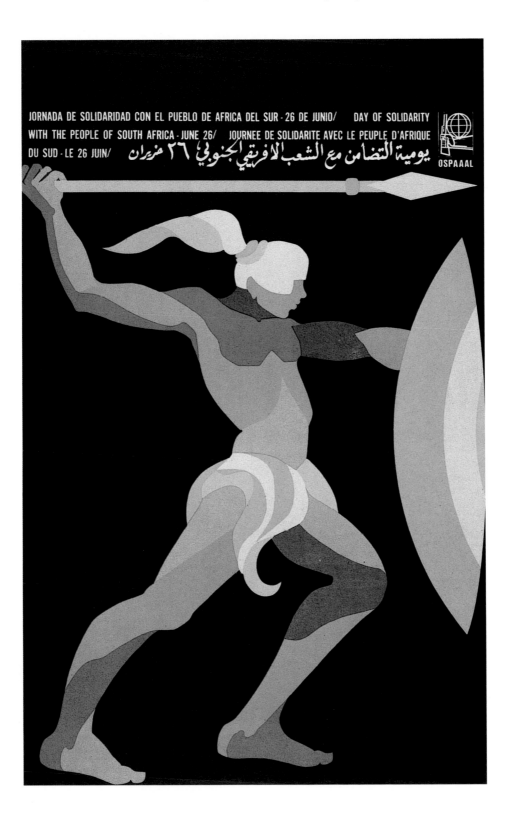

ERNESTO PADRÓN
Together with Vietnam
1971 OSPAAAL 54 x 33 cm offset

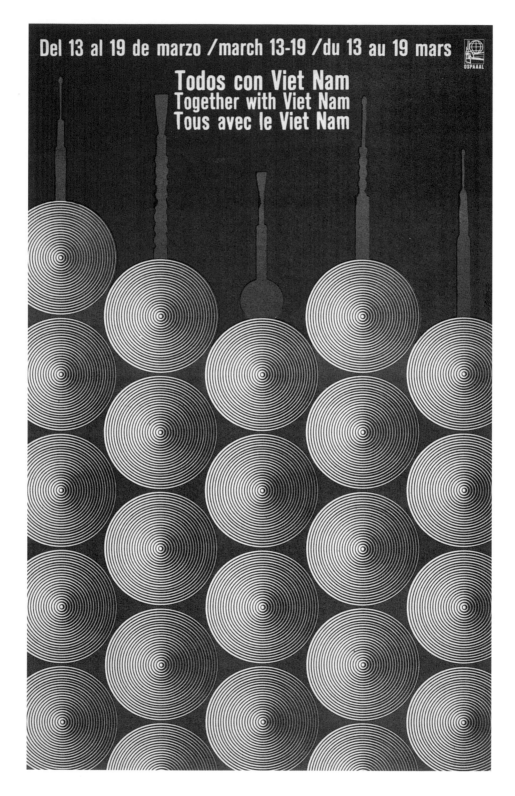

Right
ALFRÉDO ROSTGAARD
(no title) Radiant Che
1969 OSPAAAL 66 x 39 cm offset

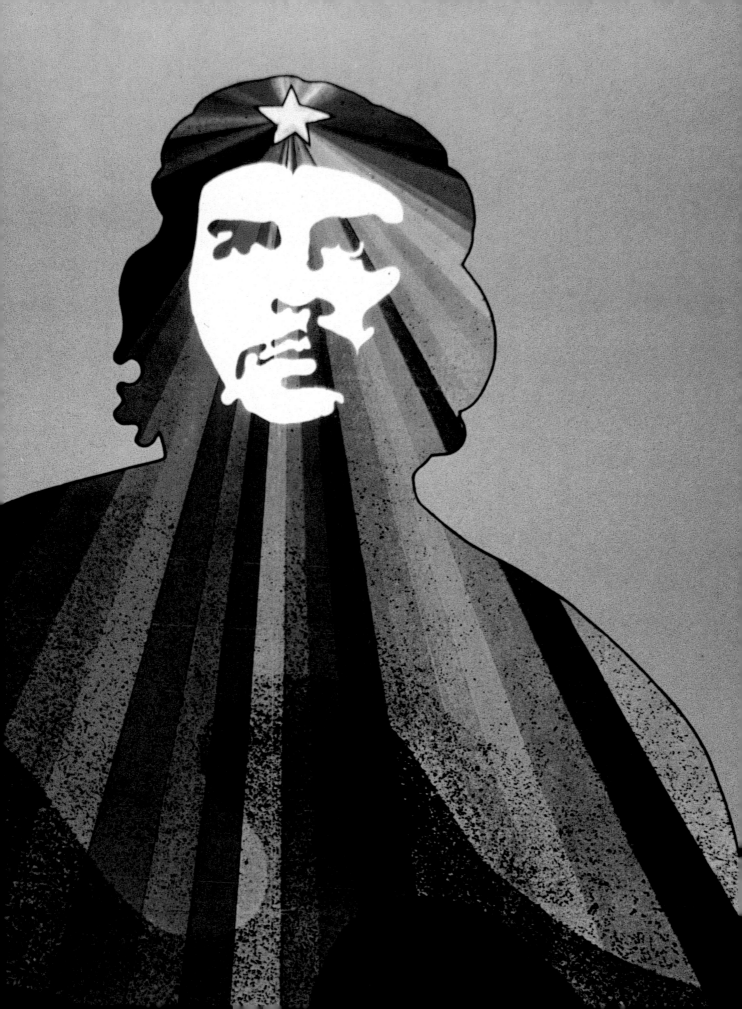

BERTA ABELENDA
*Day of Solidarity with the Arab
Peoples*
1968 OSPAAAL 53 x 33 cm offset

HERIBERTO ECHEVERRÍA
March 8—International Women's Day
1972 EP (COR) 64 x 42 cm offset

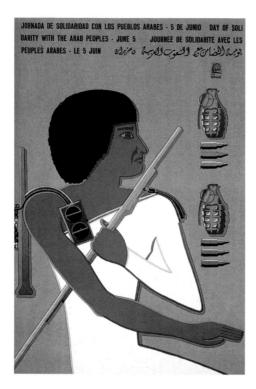

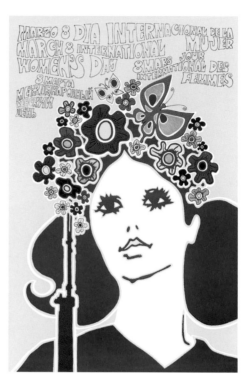

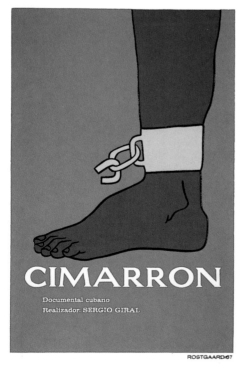

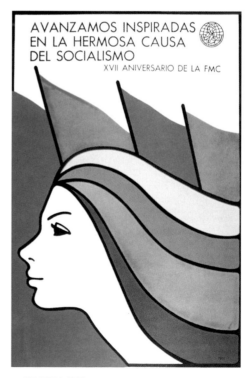

ALFRÉDO ROSTGAARD
Cimarron
1967 ICAIC 76 x 51 cm silk screen

MIGUEL NIN
*We Advance, Inspired by the
Beautiful Socialist Cause*
1977 EP 55 x 32 cm silk screen and offset

FAUSTINO PÉREZ
Day of Solidarity with Venezuela
1969 OSPAAAL 54 x 33 cm offset

ALBERTO BLANCO
Haiti—Solidarity with the Suffering People
1983 OSPAAAL 58 x 40 cm offset

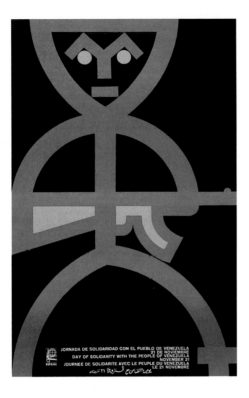

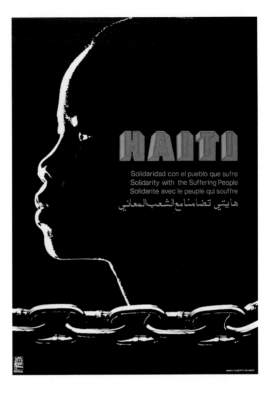

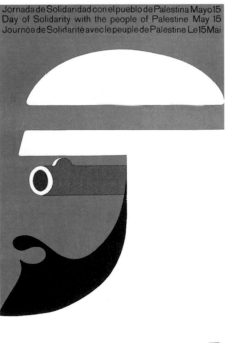

FAUSTINO PÉREZ
Day of Solidarity with the People of Palestine
1968 OSPAAAL 54 x 33 cm offset

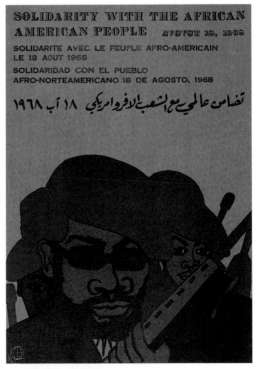

LÁZARO ABREU
Solidarity with the African American People
1968 OSPAAAL 54 x 46 cm offset

(illustration by U.S. Black Panther artist Emory Douglas)

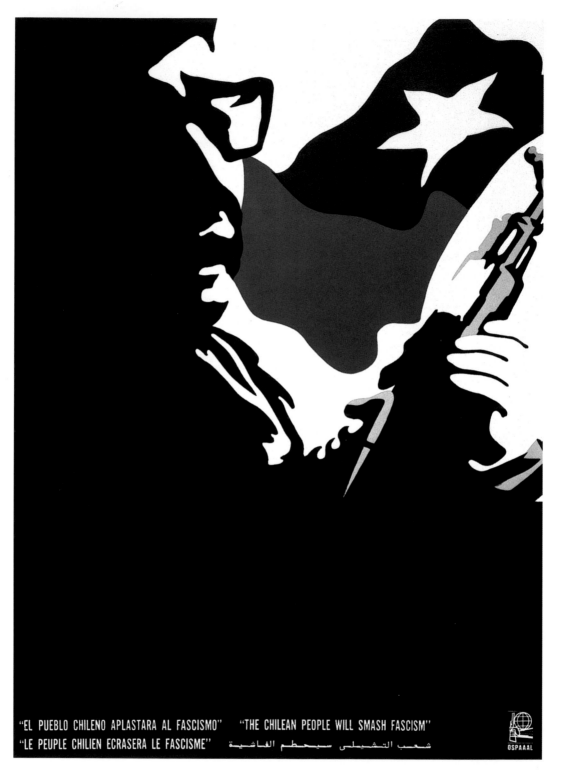

"EL PUEBLO CHILENO APLASTARA AL FASCISMO" "THE CHILEAN PEOPLE WILL SMASH FASCISM"

"LE PEUPLE CHILIEN ECRASERA LE FASCISME" شعب التشيلى سيحطم الفاشية

OSPAAAL

RAFAEL MORANTE

*Visit Grenada / A climate of freedom, a friendly
solidary [sic] people, master of its own destiny /
Beautiful and revolutionary, Grenada is nobody's
backyard, and of course it's not for sale!*

1982 OSPAAAL 74 x 49 cm offset

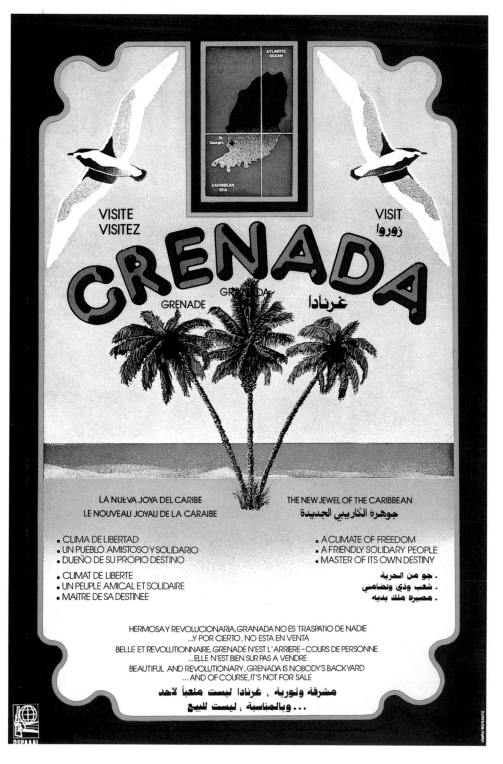

JANE NORLING
*Day of World Solidarity with the Struggle of
the People of Puerto Rico*
 1973 OSPAAAL 68 x 49 cm silk screen

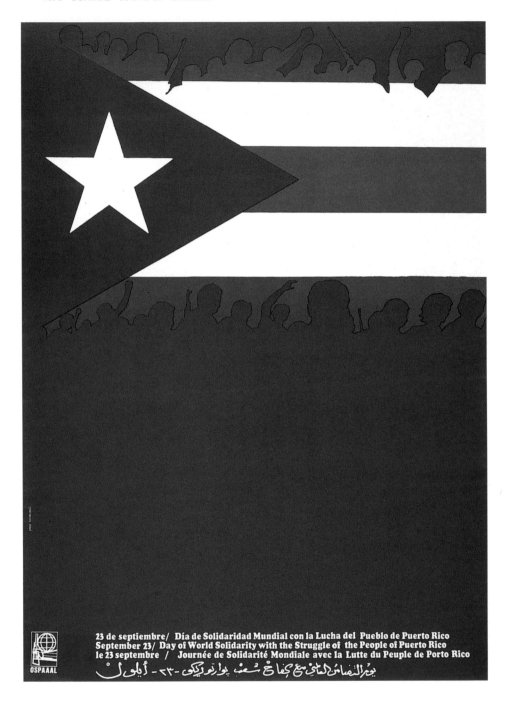

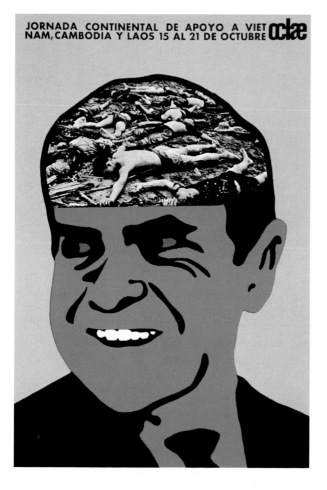

LUIS BALAGUER
Day of Continental Support for Vietnam,
Cambodia, and Laos / 12 to 21 October
 1969 OCLAE 63 x 42 cm offset

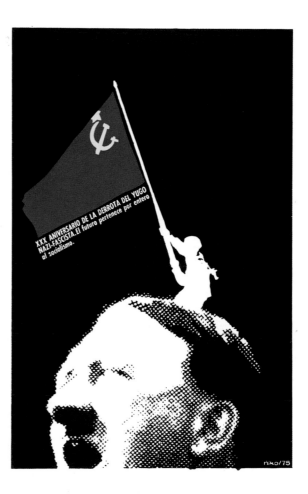

ANTONIO (ÑIKO) PÉREZ
30th Anniversary of the Fall of the Nazi-
Fascist Axis
 1975 ICAIC 76 x 51 cm silk screen

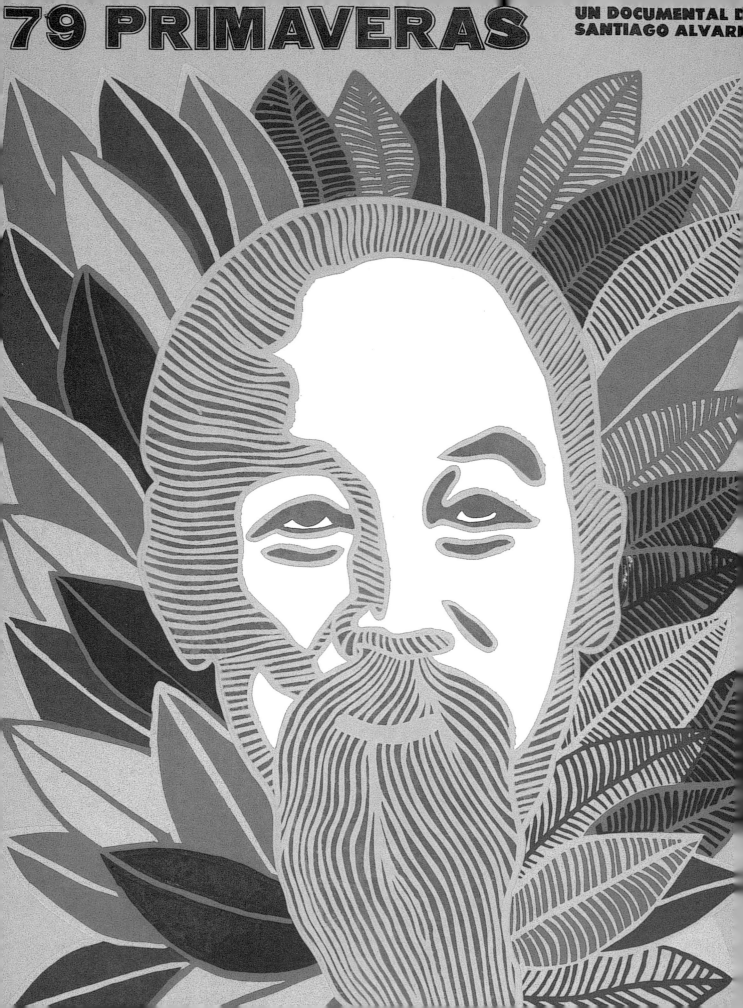

79 PRIMAVERAS

UN DOCUMENTAL D
SANTIAGO ALVARE

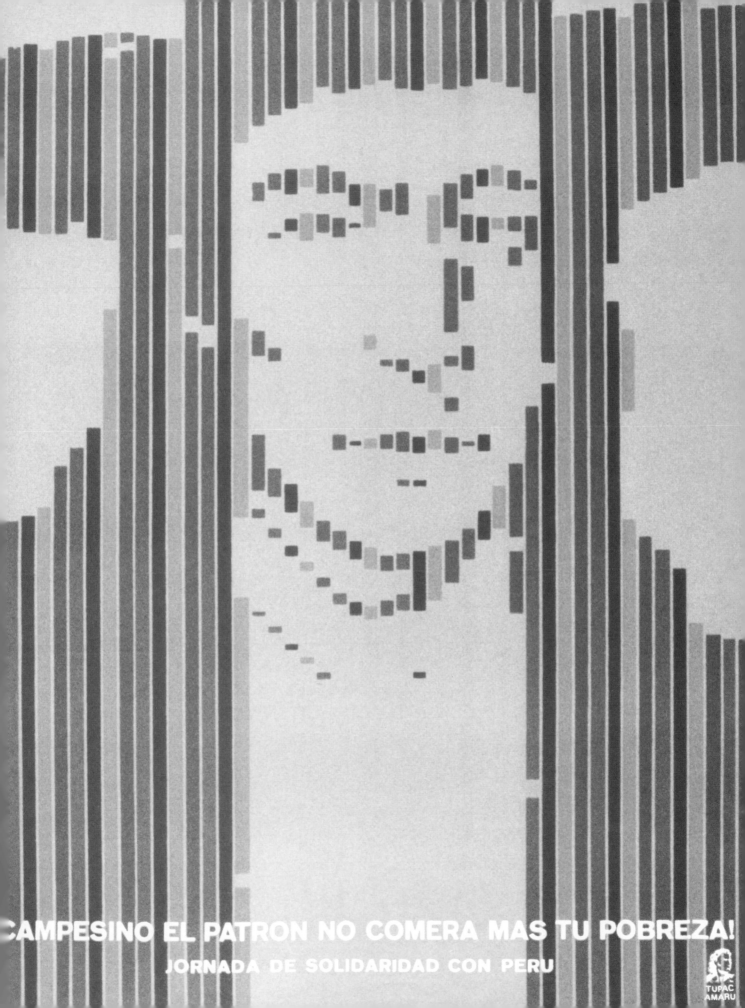

¡CAMPESINO EL PATRON NO COMERA MAS TU POBREZA!

JORNADA DE SOLIDARIDAD CON PERU

TUPAC AMARU

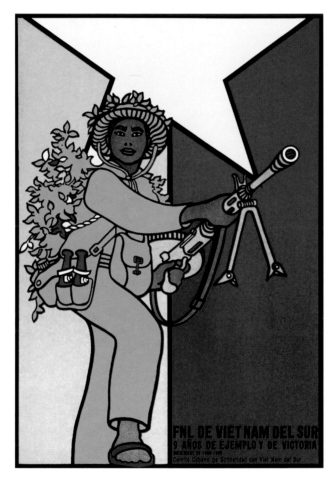

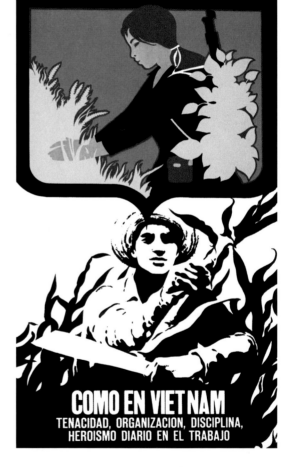

RENÉ MEDEROS
*NLF (National Liberation Front) of
South Vietnam—9 Years*
1969 EP (COR) 70 x 48 cm silk screen and offset

RENÉ MEDEROS
*As in Vietnam—Tenacity, Organization,
Discipline*
1970 EP (for Comité de Solidaridad con Vietnam del Sur)
64 x 34 cm offset

RENÉ MEDEROS
12th Anniversary of the NLF (National Liberation Front)
of South Vietnam
1972 OCLAE (published by EP) 55 x 34 cm offset

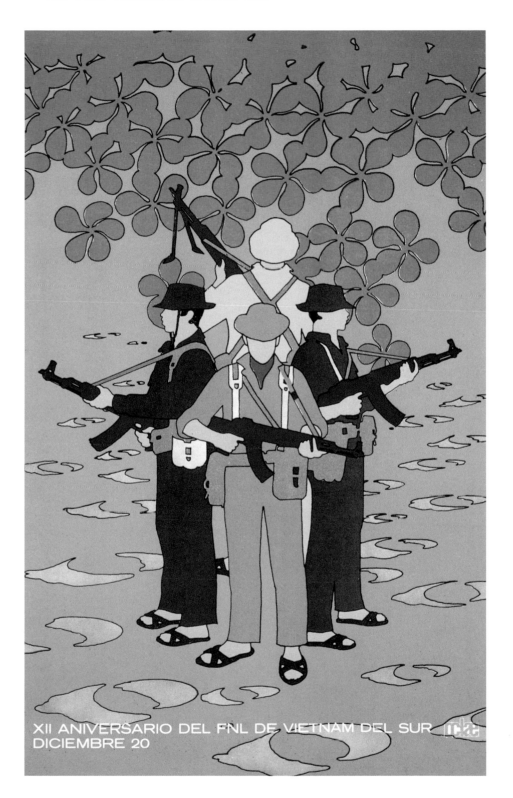

ANTONIO MARIÑO
Day of Solidarity with Guatemala
1970 OSPAAAL 53 x 33 cm offset

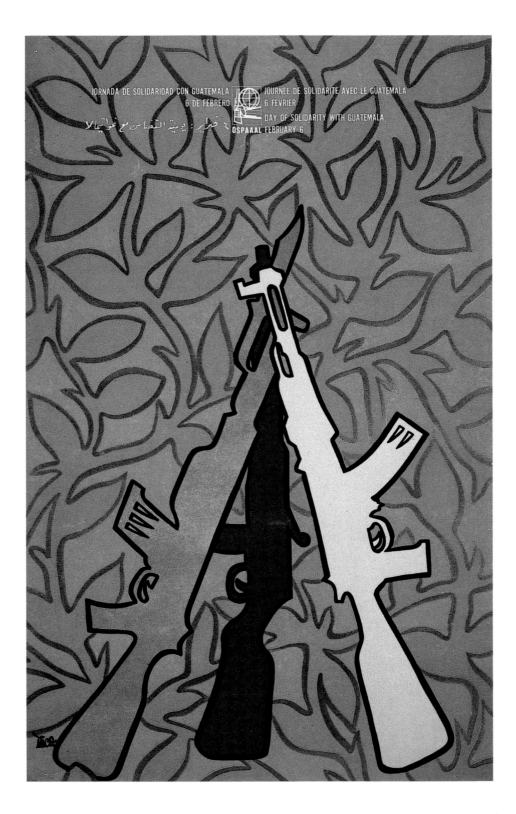

OLIVIO MARTINEZ
Guatemala
1968 OSPAAAL 55 x 34 cm silk screen

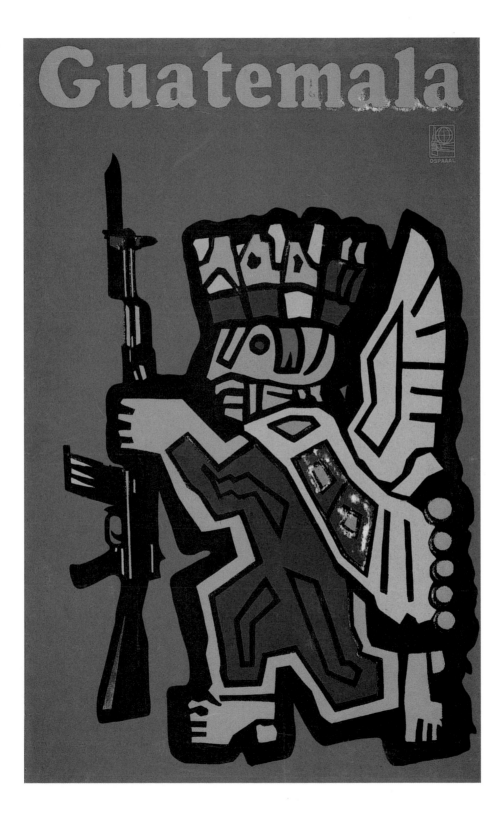

FERNANDO VALDEZ
FMC Welcomes OLAS Conference
1965 EP (for FMC) 75 x 50 cm offset

VICTOR MANUEL NAVARRETE
Solidarity with the People of South Africa
1977 OSPAAAL 71 x 42 cm offset (Sharpeville massacre)

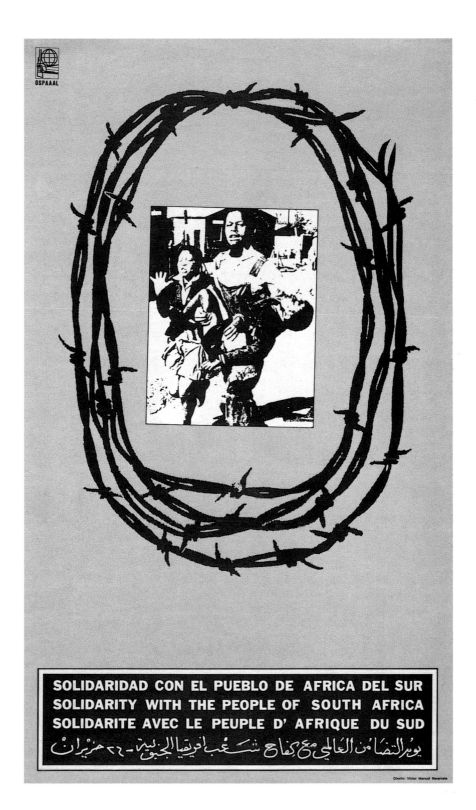

ALFRÉDO ROSTGAARD
Now!
1965 ICAIC 76 x 51 cm silk screen
(slogan of the Student Nonviolent Coordinating
Committee, a U.S. civil rights organization)

now!

Documental del ICAIC
Con la voz de LENA HORNE
Realización
SANTIAGO ALVAREZ

rostgaard/65

Right
ANTONIO (ÑIKO) PÉREZ
Luanda Is Not from San Pablo Anymore
1976 ICAIC 76 x 51 cm silk screen

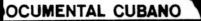

OCUMENTAL CUBANO EN COLORES DIRECCION: SANTIAGO ALVAREZ

LUANDA
YA NO ES DE
SAN PABLO

ANTONIO (ÑIKO) PÉREZ
Maputo: Meridiano Novo
1977 ICAIC 76 x 51 cm silk screen

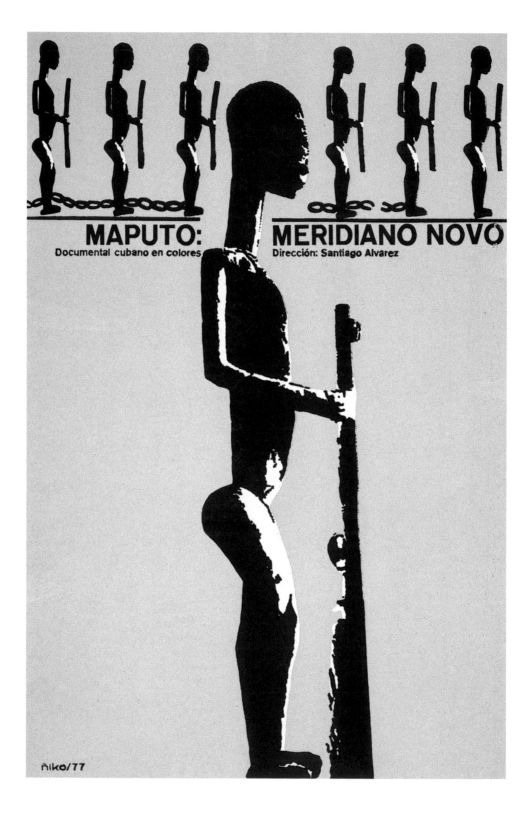

A. FERNÁNDEZ REBOIRO
Nhung: A Girl from Saigon
1975 ICAIC 76 x 51 cm silk screen

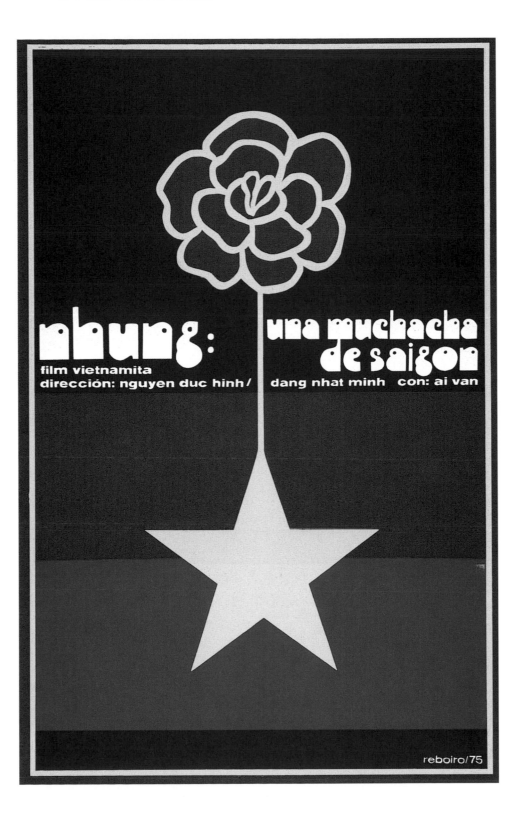

EDUARDO MUÑOZ BACHS
Ethiopia, Diary of a Victory
1979 ICAIC 76 x 51 cm silk screen

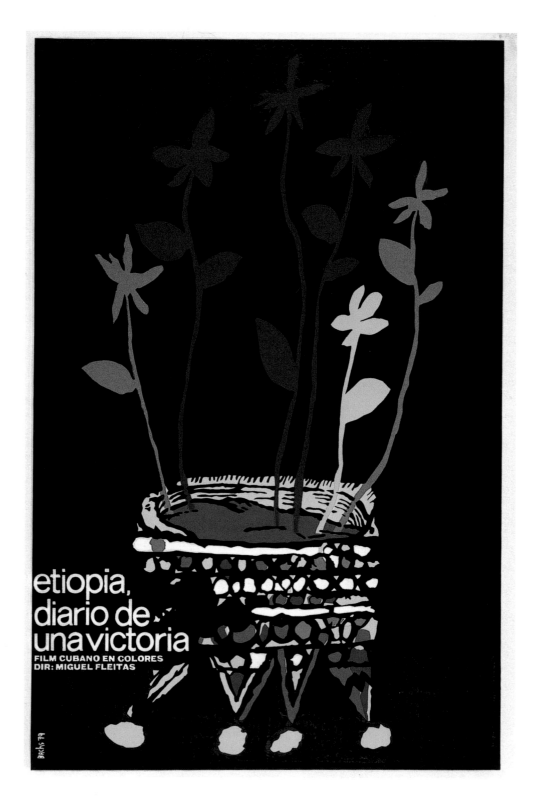

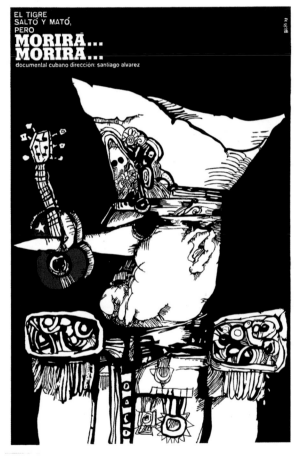

EDUARDO MUÑOZ BACHS
The Tiger Leapt and Killed, but It Will Die,
It Will Die
 1973 ICAIC 76 x 51 cm silk screen
 (Augusto Pinochet)

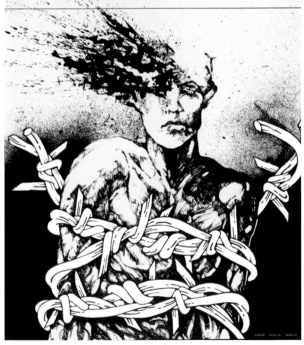

MODESTO BRAULIO
Freedom for Student Political Prisoners
in Latin America and the Caribbean
 early 1970s OCLAE 73 x 50 cm offset

FÉLIX BELTRÁN
*She Suffered Discrimination Since Childhood—Solidarity
with Angela Davis*
 1972 EP (for the Cuban Committee for the Freedom of Angela Davis)
 60 x 34 cm silk screen

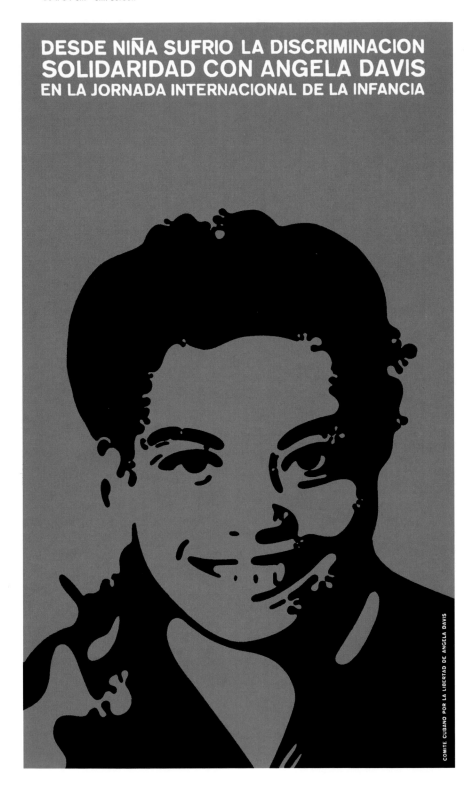

ALFRÉDO ROSTGAARD
Santo Domingo / 1965
1970 OSPAAAL 52 x 31 cm offset

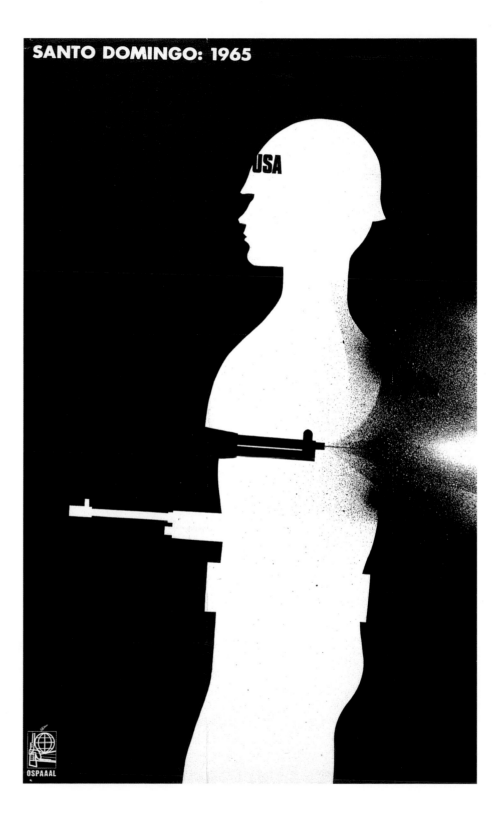

VICTOR MANUEL NAVARRETE
*World Solidarity with the Cuban
Revolution*
1980 OSPAAAL 75 x 51 cm offset

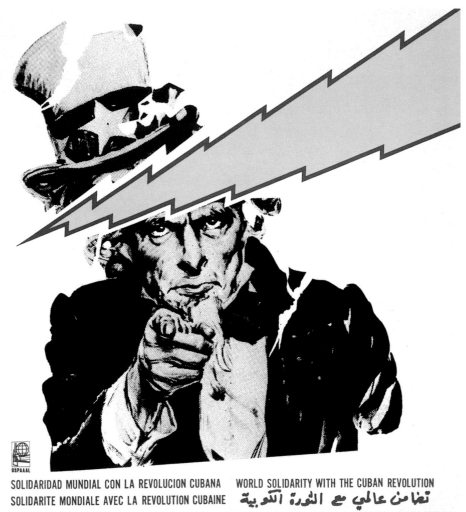

SOLIDARIDAD MUNDIAL CON LA REVOLUCION CUBANA WORLD SOLIDARITY WITH THE CUBAN REVOLUTION
SOLIDARITE MONDIALE AVEC LA REVOLUTION CUBAINE تضامن عالمي مع الثورة الكوبية

RENÉ AZCUY CARDENAS
Puerto Rico
1988 ICAIC 76 x 51 cm silk screen

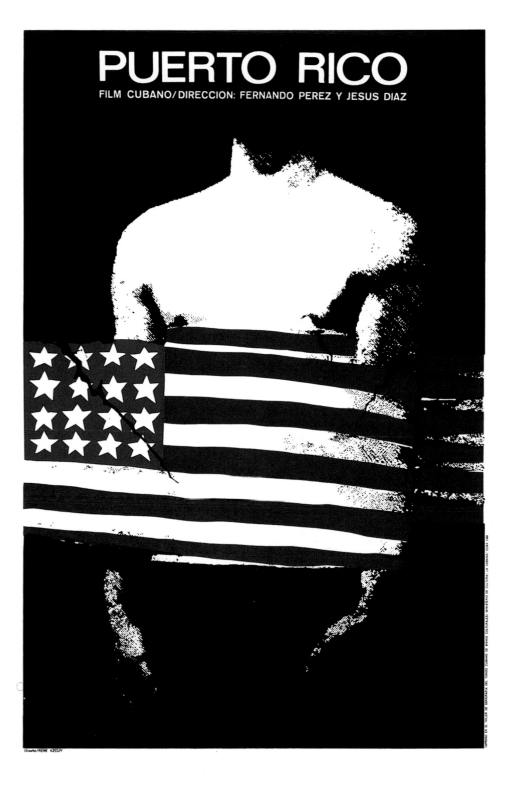

Right

HUMBERTO TRUJILLO
Anti-Imperialist Unity Is the Tactic and Strategy
for Victory (Conference in Santiago, Chile)
1973 OCLAE (published by EP) 71 x 46 cm offset

RAFAEL MORANTE
Power to the People George
1971 OSPAAAL 34 x 53 cm offset

(George Jackson was a leader of the Black Panther Party)

LA UNION ANTIMPERIALISTA
ES LA TACTICA Y LA ESTRATEGIA
DE LA VICTORIA

V CLAE

★ CHAPTER FIVE

EDUCATION AND CULTURE

EDUCACIÓN Y CULTURA

"In the morning, the pen—but in the afternoon, the plow."

—José Martí

The postrevolutionary Cuban government has established a strong record on education. Although literacy statistics from the time Batista fled the island in 1959 range from 43 percent to 80 percent,[27] there is little dispute over the data on Cuba's status at present. In 2001 a task force assessing a 1998 UNESCO (United Nations Educational, Scientific, and Cultural Organization) regionwide test of primary-school students concluded, "In test scores, completion rates, and literacy levels, Cuban primary students are at or near the top of a list of peers from across Latin America."[28] The report went on to note, "Cuba far and away led the region in third- and fourth-grade mathematics and language achievement. . . . Even the lowest fourth of Cuban students performed above the regional average." UNESCO ranks Cuba's basic literacy rate at just over 96 percent. This is all the more remarkable given that current per-student funding is less than a thousand dollars a year. Part of the reason for such high literacy rates goes back to 1961, when the new revolutionary government launched a massive literacy campaign in which all schools were closed for eight months and 120,000 volunteers worked to raise the reading level of almost a million people. Another factor may be the large number of educated professionals who, because of the slow economy, have had difficulty finding work in their fields and ended up in teaching positions.

Cuban public policy has always included a commitment to supporting universal public education, compulsory through ninth grade. Education is seen as essential to building the new socialist man and woman. The role of an intelligent populace, articulate in the relative merits of socialism over capitalism, is promoted as a defense against corrupt foreign influences in martial terms—"Education: A weapon against the enemy," pro-

claims one poster. It is also significant that, given Cuba's mostly rural population, it has risen to the dual challenge of educating agricultural workers and breaking down social divisions between city and countryside. In 1971 Cuba established the "Secondary Schools in the Countryside" campaign, in which students spent summers on farms and in orchards, dividing their time between their studies and bringing in the harvest. This approach is captured in the poster *Alongside the Workers Harvesting Wealth*, with interwoven images of tobacco leaves, books, and sugarcane.

Like education, Cuban cultural development since the revolution has been shaped by the influence of state support. Posters proclaim a multitude of public events, including music festivals, art exhibitions, and graphic arts conferences. Cuban music—everything from traditional folk music to Afro-Cuban drumming to jazz and rock—is a popular form of expression that pulsates from clubs and concert halls. Art exhibits both large and small are often promoted with powerful graphic art. But the cultural activity most expressed through the poster art form has been cinema. What has been exceptional is that not only does the "advertising" division of ICAIC produce posters for Cuban films, it does so for all films shown in Cuba. Approximately one-third of the films promoted are Cuban; the rest come from all over the world. It is fascinating to see the range of countries, directors, and topics that appear in ICAIC's posters. Films by Kurosawa, Hitchcock, and Buñuel are all repackaged through Cuban eyes, often by artists interpreting the movie's theme rather than promoting a particular actor or director. Compare this approach to the conventional Hollywood-style advertisement featuring close-ups of box-office stars and you begin to see the radical departure these

posters represent. Conversely, because these are also limited-edition silk screen prints, the ICAIC posters are also the form of the Cuban poster that most closely mimics the fine art collectible and commercial prints sold in galleries around the world.

★

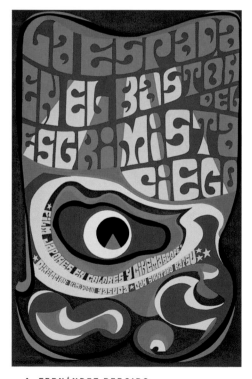

A. FERNÁNDEZ REBOIRO
The Sword in the Baton of the Blind Escrima Fighter
 1968 ICAIC 76 x 51 cm silk screen
 (escrima is a martial art)

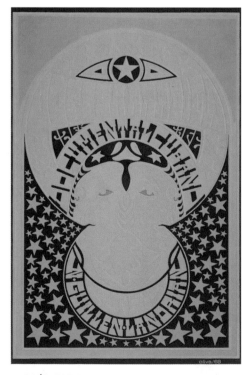

RAÚL OLIVA
Arabian Coffee
 1968 ICAIC 76 x 51 cm silk screen

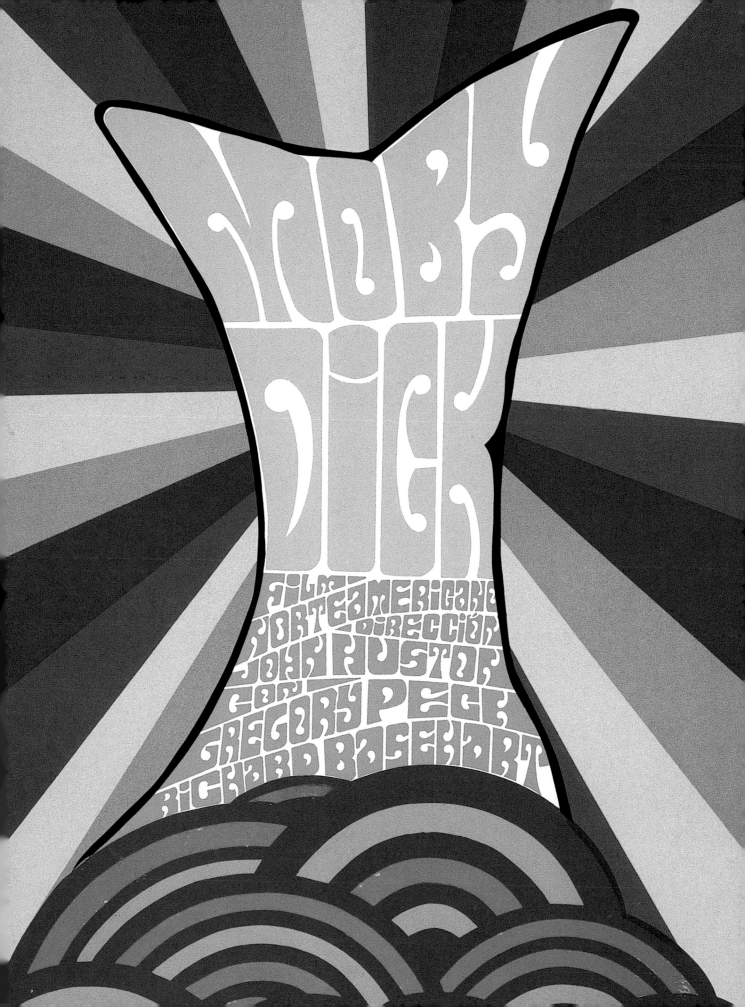

FRANCISCO MASVIDAL
*1st Conference on UNEAC
Graphic Design*
1979 EP 74 x 49 cm silk screen

ARTURO ALFONSO PALOMINO
*Education / A Weapon Against the
Enemy*
1972 EP (for MININT) 65 x 40 cm silk screen

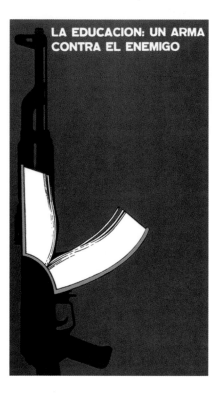

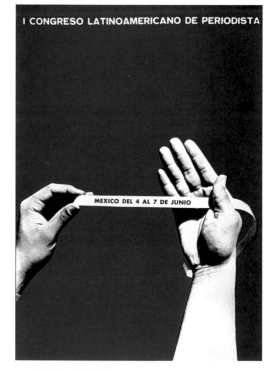

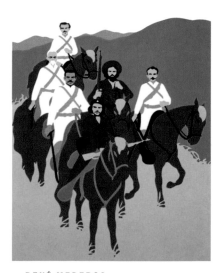

GLADYS ACOSTA
*1st Latin American Congress of
Journalists / Mexico, June 4–7*
1976 EP (for UPEC) 74 x 54 cm offset

RENÉ MEDEROS
Exposition
1971 EP (COR) 38 x 18 cm silk screen
(FIGURES, LEFT TO RIGHT: Máximo Gomez, Eduardo
Agramonte, Quintín Bandera, Che Guevara,
Camilo Cienfuegos, José Martí.)

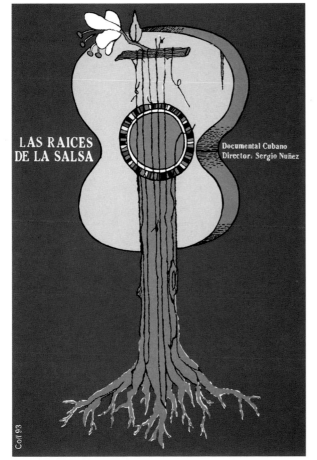

NESTOR COLL

The Roots of Salsa

1993 ICAIC 76 x 51 cm silk screen

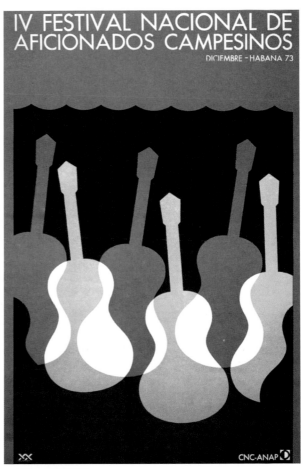

LUIS ALVAREZ

4th National Folk Music Festival

1973 EP (DOR, for CNC and ANAP) 65 x 40 cm offset

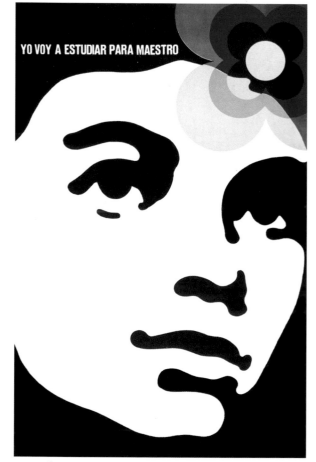

RENÉ MEDEROS
I Am Going to Study to Be a Teacher
1971 EP (for MINED) 59 x 41 cm offset

RENÉ AZCUY CARDENAS
Week of Cuban Film
1976 ICAIC 76 x 51 cm silk screen
(poster for a Cuban film festival in Italy)

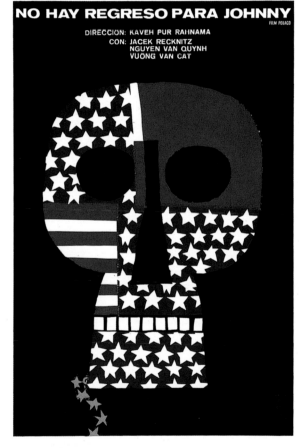

EDUARDO MUÑOZ BACHS
Johnny's Not Coming Home
1971 ICAIC 76 x 51 cm silk screen

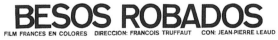

RENÉ AZCUY CARDENAS
Stolen Kisses
1970 ICAIC 76 x 51 cm silk screen

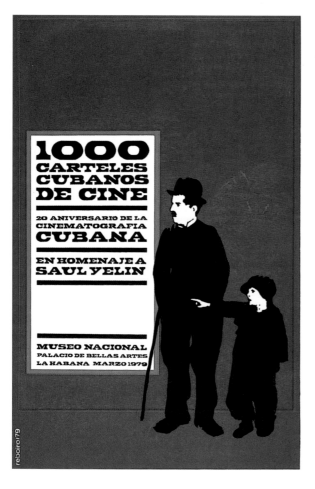

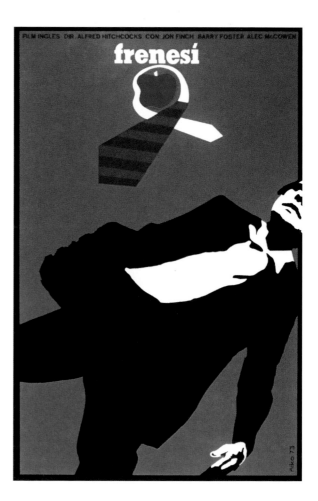

A. FERNÁNDEZ REBOIRO
1000 Cuban Film Posters
1979 ICAIC 76 x 51 cm silk screen

ANTONIO (ÑIKO) PÉREZ
Frenzy
1977 ICAIC 76 x 51 cm silk screen

ALFRÉDO ROSTGAARD
ICAIC Tenth Anniversary
1969 ICAIC 76 x 51 cm silk screen

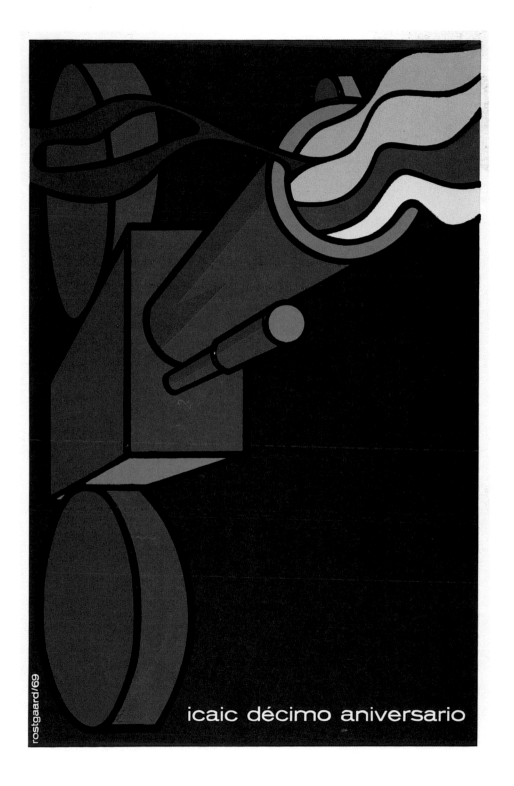

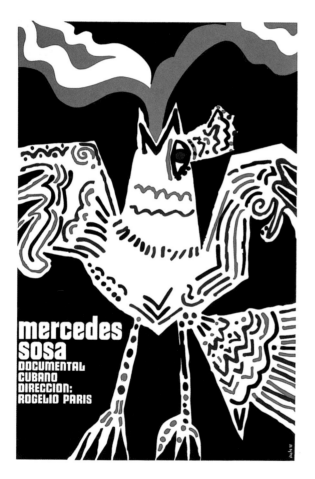

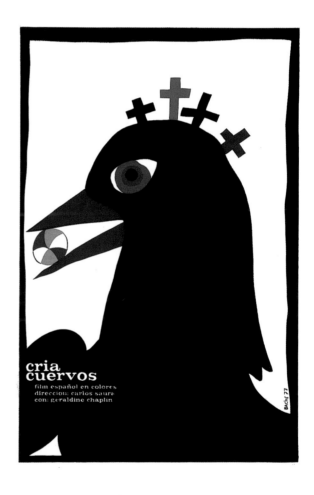

EDUARDO MUÑOZ BACHS
Mercedes Sosa
1975 ICAIC 76 x 51 cm silk screen

EDUARDO MUÑOZ BACHS
Breeding Crows
1977 ICAIC 76 x 51 cm silk screen

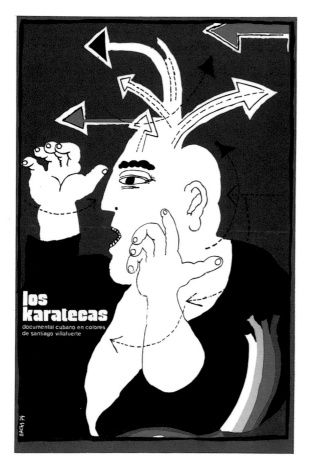

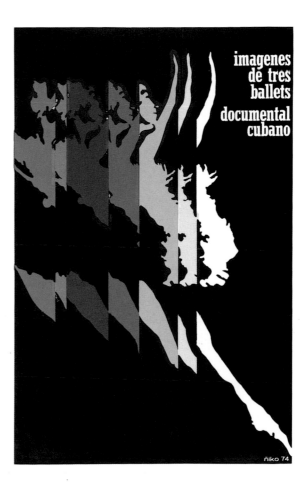

EDUARDO MUÑOZ BACHS
The Karate Fighters
1979 ICAIC 76 x 51 cm silk screen

ANTONIO (ÑIKO) PÉREZ
Images of Three Ballets
1974 ICAIC 76 x 51 cm silk screen

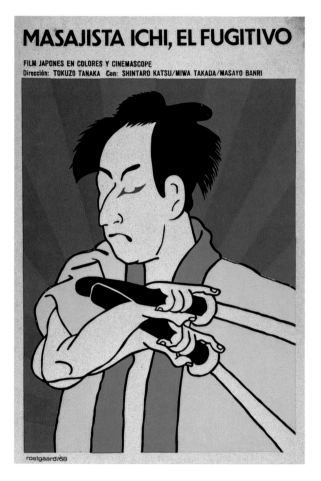

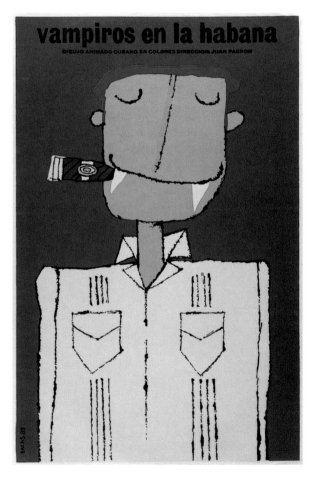

ALFRÉDO ROSTGAARD
Masajista Ichi, the Fugitive
1968 ICAIC 76 x 51 cm silk screen

EDUARDO MUÑOZ BACHS
Vampires in Havana
1985 ICAIC 76 x 51 cm silk screen

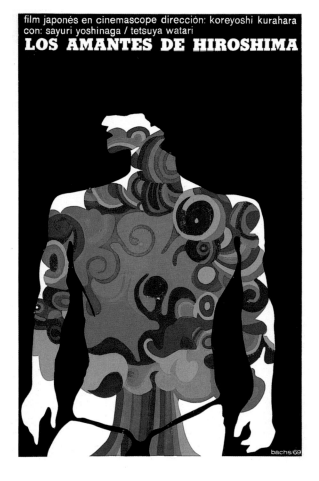

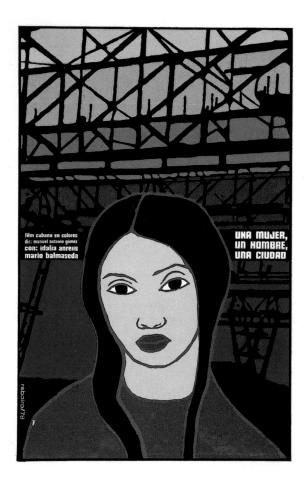

EDUARDO MUÑOZ BACHS
The Lovers of Hiroshima
1969 ICAIC 76 x 51 cm silk screen

A. FERNÁNDEZ REBOIRO
A Woman, A Man, A City
1978 ICAIC 76 x 51 cm silk screen

NOTES

ACRONYMS REFERRED TO IN CUBAN POSTERS

ANAP – Asociación Nacional de Agricultores Pequeños (National Association of Small Farmers)

CCPCC – Comité Central del Partido Comunista de Cuba (Central Committee of the Cuban Communist Party)

CNC – Comité Nacional de Coordinación (National Coordinating Committee)

COR – Comisión de Orientación Revolucionario (Commission of Revolutionary Orientation)

DOR – Departamento de Orientación Revolucionario (Department of Revolutionary Orientation)

EP – Editora Política (Political Publishing [Department of the CCPCC])

FMC – Federación de Mujeres Cubanas (Federation of Cuban Women)

ICL – Instituto Cubano del Libro (Cuban Book Institute)

ICAP – Instituto Cubano de Amistad con los Pueblos (Cultural Institute for Friendship between the Peoples)

ICAIC – Instituto Cubano de Arte e Industria Cinematográficos (Cuban Institute of Cinematic Art and Industry)

INDER – Instituto Nacional de Educación Física y Recreación de Cuba (Cuban National Institute of Education and Physical Recreation)

MINED – Ministerio de Educación (Ministry of Education)

MININT – Ministerio del Interior (Ministry of the Interior)

MINSAP – Ministerio de Salud Publica (Ministry of Public Health)

OCLAE – Organización Caribeña y Latinoamericana de Estudiantes (Latin American and Caribbean Students' Association)

OSPAAAL – Organización de Solidaridad de los Pueblos de Africa, Asia y América Latina (Organization in Solidarity with the People of Africa, Asia, and Latin America)

UJC – Unión de Jovenes Comunistas (Union of Young Communists)

UNEAC – Unión Nacional de Escritores y Artistas de Cuba (Cuban National Union of Writers and Artists)

UPEC – Unión de Periodistas de Cuba (Cuban Journalists Union)

1 Viet Nam is the spelling used by the Vietnamese (their language is monosyllabic), which is the form used by the Cubans. The single-word version is a legacy of the French colonialists and is the preferred U.S. spelling.

2 Although the "golden age" has been formally described as being from 1966 to 1972, the posters in this book cover a slightly broader time period.

3 Fidel Castro, *"Palabras a los intelectuales,"* speech delivered in August 1961. The quote continues: "Against the Revolution, nothing, because the Revolution also has its rights, and the first right of the Revolution is the right to exist, and no one may stand before this right of the Revolution to be and to exist. As long as the Revolution understands the interests of the people, as long as the Revolution means the interests of the whole nation, no one may reasonably allege a right against it." Source: Jorge R. Bermúdez, *La Imagen Constante,* (Havana: Editorial Letras Cubanas, 2000) p. 82.

4 Fidel Castro, quoted in Michael Chanan, *The Cuban Image* (London: British Film Institute, 1985), referenced in David Kunzle, *Che Guevara: Icon, Myth, and Message* (Los Angeles: UCLA Fowler Museum of Cultural History, 1997).

5 Eladio Rivadulla Pérez, *La serigrafía artistica en Cuba* (Havana: Ediciones Unión [UNEAC], 1996), p. 42.

6 David Kunzle, "Public Graphics in Cuba," *Latin American Perspectives* issue 7, supplement, volume 2, number 4 (1975), p. 90.

7 Adelaida de Juan, "Three Essays on Design," *Design Issues* volume 16, number 2 (Summer 2000), pp. 45–48.

8 Yelin's contribution was commemorated in a 1979 exhibit; see poster, p.108 left.

9 Anecdote provided by artist Jane Norling, who worked with OSPAAAL in 1973.

10 *1000 carteles cubanos de cine: 20 aniversario de la cinematografía cubana,* catalog for the Exposition in Homage to Saúl Yelin and the twentieth anniversary of postrevolutionary Cuban cinema (Havana: ICAIC, 1979).

11 Data culled form poster collection card catalog at the *Biblioteca Nacional José Martí*, (BNJM), Cuba's national library.

12 I was told by an ICAIC official in 1993 that the agency was creating approximately twenty new titles a year, and reissuing about thirty. I was told by the head of the silk-screen crew that they are actually doing between four and ten new posters a year.

13 This closely matches the number of three thousand estimated by the production staff at ICAIC.

14 This is an educated guess, based on the acquisition number of 5,137 in EP's records, as inspected by the author in 1985. In 1983, the person assigned archival records duty (Mirta Muñiz) told me that EP's archive included about five thousand posters.

15 País was the head of the underground urban revolutionary movement; his death in 1957 prompted mass demonstrations.

16 I was told by the production manager at the ICAIC silk-screen facility that typical runs were between two hundred and fifteen hundred.

17 Printed 95-x-152-cm sheets were assembled in twelve-segment billboards called *vallas.* The largest press is a *Planeta Polygraph,* capable of printing sheets up to 70 x 100 cm.

18 Among other purposes, the poster raised funds for the San Francisco–based organization Medical Aid for Indochina. The poster was most recently reproduced in a perpetual calendar collaboratively produced by the Syracuse Cultural Workers and the Center for the Study of Political Graphics.

19 The show was organized by Juan Fuentes and Susan Adelman and went on to San Jose, California, and Albuquerque, New Mexico.

20 David Kunzle, *Che Guevara; Decade of Protest—Political Posters from the United States, Vietnam, and Cuba 1965–1975,* catalog for exhibit at Track 16 Gallery, Santa Monica, California (Santa Monica: Smart Art Press, 1996); Center for Cuban Studies, *Rostgaard: A Retrospective—Cuban Revolutionary Posters,* catalog for exhibit in New York, July 5–August 31, 2001(New York: Cuban Art Space/Center for Cuban Studies, 2001).

21 Quoted in Christopher Baker, *Cuba* (Emeryville, Calif: Avalon Travel Publishing, 2000), p. 28.

22 W. E. Woodward, *A New American History* (New York: Garden City Publishing, 1936), p. 687.

23 Estimated direct costs of the embargo include higher freight charges, a higher cost of imports, lower export revenues, and poor currency exchange values, which total as much as $800 million a year, or 20 percent of Cuba's current import bill. Pedro Monreal, "Sea Changes: The New Cuban Economy" (New York: NACLA Report on the Americas [North American Congress on Latin America], March/April 1999) p. 27.

24 U.S. Central Intelligence Agency, *The World Factbook—Cuba,* 2002; http://www.odci.gov/cia/publications/factbook/geos/cu.html

25 Ibid.

26 Quoted in speech by Nelson Mandela commemorating the tenth anniversary of the death of Samora Machel, October, 1996.

27 Christopher Baker, *Cuba,* p. 115.

28 Christopher Marquis, "Cuba's Schools Shine Despite Few Resources," *The San Francisco Chronicle,* December 20, 2001.

29 http://www.unites.uqam.ca/cuba/affiche.htm

★

Lazaro Abreu and Olivio Martinez, 1996

Eduardo Muñoz Bachs and René Mederos, 1994

THE ARTISTS

All artwork, even a political poster, is a creative process that depends on the talents of individuals. In an effort to properly give credit to those Cuban graphic artists who poured their hearts and souls into these works, I have tried to compile as much biographical information as possible about the contributors to the posters in this book. The lack of detail available is one more example of the need for further scholarship in this field.

Sources used for information include exhibit catalogs listed in the bibliography; *Cuba en la gráfica,* by Reyna Maria Valdés (Ediciones Gianni Constantino S.A., 1992, Italy); material available on the World Wide Web from a 1999 exhibit, *Affiches de Cuba 1959–1996,* curated by Raymond Vézina, professor at the Université du Québec in Montréal, Canada,[29] and information supplied by Alberto Blanco and Marla Hoffman.

(KEY: Top=T; Bottom=B; Right=R; Left=L)

Abelenda, Berta (71, 74 TL)
 1925– (deceased, date unknown).

Abreu Padrón, Lázaro (75 BR)
 1941–

Acosta Avila, Gladys (44, 104 BL)
 1941–2001 Staff graphic artist at Editora Política and then OSPAAAL.

Alfonso Palomino, Arturo (104 TR)

Alvarez, Luis (50, 105 R)

Bachs, Eduardo Muñoz (46 R, 92, 93 L, 107 L, 110 L, 110 R, 111 L, 112 R, 113 L)
 1937 (Valencia, Spain)–2001 (Havana, Cuba). Bachs was the most prolific of all Cuban artists. Although he worked briefly at COR, the bulk of his work was through ICAIC. In addition to poster design, he was well known for children's book illustrations and book covers. He had numerous one-man shows in Havana and abroad, and his work is held in the permanent collections of major museums around the world.

Balaguer, Luis (79 L)

Alfrédo Rostgaard, 1999

*Gertrud Ludtke and Luis Martínez-Pedro,
late 1950s (Christmas card)*

René Mederos and author at EP office, 1993

Beltrán, Félix (6, 35, 81, 94)

1938 (Havana, Cuba)–(emigrated to Mexico 1979). Beltrán studied at the School of Visual Arts in New York City and returned to Cuba immediately following the revolution. He is an internationally recognized designer and author and is director of Félix Beltrán Associates, a graphic design firm in Mexico City.

Blanco, Alberto (69, 75 TR)

1955 (Havana, Cuba)–(emigrated to New York 1991). Blanco studied at the former National School of Design in Havana (renamed the Instituto Superior de Diseño Industrial in 1984). He was a staff designer at OSPAAAL from 1975 to 1991. In 1974, while he was still in the armed forces, his poster won first prize at the National Poster Salon. In 1997 he designed the logo for the Cuba-Korea Friendship Committee.

Braulio, Modesto (93 R)

Cardenas, Rene Azcuy (97, 106 R, 107 R)

1939 (Havana, Cuba)–. Azcuy exhibited at every National Poster Salon and has participated in numerous international shows. He has been a designer in the publicity department at the National Film Distribution Center of the Ministry of Culture and is a member of UNEAC.

Coll, Nestor (105 L)

Nestor Coll is currently a staff designer at ICAIC.

Cruz, Raul F. (16)

Del Pozo, Heriberto C. Echeverría (Heri) (41 TR, 46 L, 51, 74 TR)

1932 (Havana, Cuba)–. "Heri" joined COR, the early incarnation of Editora Política, in the early 1960s and worked there for many years.

Díaz, Estela (41 BL, 58, 59 R)

Enríquez, Rafael (67 TR, 67 BR, 68 L, 68 R)

Designer at OSPAAAL.

Figueredo, Roberto (26)

Designer at Editora Política.

Forjáns, Jesús (49, 59 L)

1928 (Havana, Cuba)–.

Fundora, Israel (55 L)

Currently lives in the Dominican Republic.

Alberto Blanco at OSPAAAL, 1989

Nestor Coll, 1994

Raúl Martínez in his studio, late
1970s (photo by Eva Cockcroft)

García Lopez, Daysi (41 BR, 54)
1942–(deceased, date unknown).

García Peña, Ernesto (76)

Gómez, Juan Antonio (31, 39, 41 TL, 43, 47, 57 R)
(Note: biographical data exists for two Cuban artists with similar names. At present it is unknown which posters were created by which person.)

Gómez, Juan A. (Tito)
1943 (Havana, Cuba)–. Among his many national and international exhibitions, Gómez won an honorable mention at the National Poster Salon in 1980–1981 and again in 1989.

Gómez, Juan Antonio Carbonell
1952 (Matanzas, Cuba)–. Gómez holds a degree in art history from the National School of Art in Havana. He won first prize at the Nordic People's Friendship Society Symbol–Logotype Competition in 1979 and another award at the First Iberoamerican Festival of Theater in Spain, 1986.

Lamas, Jose (53)

Mariño, Antonio (Ñiko) (84)
1935–(deceased, date unknown).

Martínez, Raúl (29 L, 29 R)
1927 (Ciego de Avila, Cuba)–1995. Martínez graduated from the Chicago Institute of Design in 1953 and was a painter, engraver, designer, muralist, book designer, and photographer.

Martínez-Pedro, Luis (8)
1910 (Havana, Cuba)–1990. Martínez-Pedro enrolled in the School of Architecture at the University of Havana in 1929 but completed his studies at Tulane University in New Orleans; he returned to Cuba in 1933. Martínez-Pedro was considered one of the most significant abstract painters of what is called the "third generation," active during the 1950s. He often exhibited in New York, and he expanded his artistic skills to include dance wardrobe, stage design, industrial design, and murals. He was awarded the Order of Félix Varela, First Class, by the Cuban Ministry of Culture in 1981.

Martínez Viera, Olivio (66, 70 L, 85)
1941–

Masvidal, Francisco (104 TL)
1947 (Havana, Cuba)–. Masvidal studied art history at the University of Havana and won an award at the Eleventh National Poster Salon in 1979.

Mederos Pazos, René (14, 17, 19, 25, 28, 32, 33, 45, 67 BL, 82 L, 82 R, 83, 104 BL, 106 L)
1933 (Sagua la Grande, Cuba)–1996 (Havana, Cuba). René Mederos began creating his first posters in 1964 while working with the propaganda organization Intercommunications. The artwork he created when sent to Vietnam in 1969 and in 1972 became the basis for posters and national postage stamps. He also painted a famous series on the life of Che Guevara. Although he did some work for OSPAAAL, most of his designs were for COR and DOR, and he held the position of art director for Editora Política until his death. Mederos was a self-taught artist whose work established a unique standard for illustration and design and influenced a generation of graphic artists.

Morante Boyerizo, Rafael (34, 77, 98)
1931 (Madrid, Spain)–. Morante won the Special Prize of the Federation of Cuban Women at the National Poster Salon in 1984.

Navarrete, Victor Manuel (87, 96)
Emigrated to the Unites States 1980.

Nin, Miguel Angel (74 *BR*)

Norling, Jane (78)
1947–(Washington, D.C). North American muralist, painter, and graphic artist who worked with OSPAAAL in 1973.

Oliva, Raúl (102 R)
1935 (Ciego de Avila, Cuba)–. Trained as an architect, Oliva has participated in many national and international exhibits; he won the first prize in Scenic Design at the Havana Theater Festival in 1981.

Padrón, Ernesto (56 *R*, 72)

Papiol, José (42, 55 *R*)

Pérez Bolado, Asela (64)
1934 (Cardenas, Cuba)–. Pérez received a degree in journalism from the University of Havana. In addition to numerous international exhibitions, she won first prize in major Cuban exhibitions, including National Poster Salon in 1978. She has served as staff graphic artist for Editora Política.

Pérez González, Antonio (Ñiko) (79 R, 89, 90, 108 R, 111 R)

1941 (Havana, Cuba)–. Ñiko has a degree in art history and won first prize at the International Film Poster contest in Paris in 1975–1976. His work has been shown in international exhibits in Czechoslovakia, Italy, Poland, Colombia, and Finland.

Pérez Organcro, Faustino (27, 30 l, 40, 57 L, 70 R, 75 TL, 75 BL)

1947 (Banes, Cuba)–. Pérez studied art history at the University of Havana and became a staff graphic artist for DOR. He won an award at the First National Poster Salon in 1969 and again in1971.

Portrillé, Eduardo Murín (56 L)

1941–. Portrillé has won 29 national and 2 international awards.

Reboiro, Antonio Fernández (80, 91, 102 L, 103, 108 L, 113 R)

1935 (Nuevitas, Cuba)–. Winner of the grand prize at the International Film Poster competition in Cannes, France, 1976, he has exhibited in numerous other international shows, including ones in Czechoslovakia, Poland, and Italy.

Rivadulla Pérez, Eladio (30 R)

1959 (Havana, Cuba)–. Currently working in Ecuador. Rivadulla, son of the well-known Cuban poster artist of same name, holds a degree in art history and was the art director at OSPAAAL from 1993 to 2001.

Rostgaard, Alfrédo J. Gonzalez (2, 65, 67 TL, 73, 74 BL, 88, 95, 109, 112 L)

1943 (Guantánamo, Cuba)–. Rostgaard is of mixed ancestry (Jamaican-Chinese-Dutch-Cuban) and earned a degree at the School of Plastic Arts in Santiago de Cuba. Soon after the revolution, he worked as a cartoonist and artistic director of the Union of Young Communists' magazine *Mella*. He designed numerous posters for ICAIC and became OSPAAAL's art director from 1960 to 1975. He has had numerous international exhibits and won several international awards.

Serrano, Elena (63)

Trujillo, Humberto (38, 99)

Valdez, Fernando (86)

★

BIBLIOGRAPHY

1000 carteles cubanos de cine: 20 aniversario de la cinematografía cubana. Catalog for the *Exposition in Homage to Saúl Yelin* and the twentieth anniversary of postrevolutionary Cuban cinema, 1979. Havana: ICAIC, 1979 (30 pages, illustrated).

The Art of Revolution. Dugald Stermer, with an introductory essay by Susan Sontag. New York: McGraw-Hill Books, 1970 (98 pages, oversize, with color plates).

"Un cartel para tres continentes [A poster for three continents]." Jorge Rodriguez Bermúdez. *Tricontinental,* no. 133 (January 1996): Havana (OSPAAAL) (pages 32–37, illustrated).

Che Guevara: Icon, Myth, and Message. David Kunzle. Catalog for exhibit October 5, 1997–February 1, 1998. Los Angeles: UCLA, Fowler Museum of Cultural History/Center for the Study of Political Graphics, 1997 (124 pages, with color plates).

Cuba. Christopher P. Baker. Emeryville, CA: Moon Handbooks–Avalon Travel Publishing, 2000 (828 pages).

Cuba en la gráfica. Rayna Maria Valdés. G. Constantino, Italy, 1992. (128 pages, heavily illustrated in color).

"A Cuban Artist Views North Vietnam." Karen Wald. *Ramparts,* vol. 8, no. 10 (April 1970), Berkeley. Pages 21–27, with color plates. (Dugald Stermer, coauthor of *The Art of Revolution,* was the art director for *Ramparts* from 1964 until 1970, just before this article appeared.)

Cuban Poster Art: A Retrospective 1961–1982. Center for Cuban Studies, with an introduction by Eva Cockcroft. Catalog produced for exhibit at the Westbeth Gallery, New York, January 1983. New York: Center for Cuban Studies, 1983 (32 pages, with color plates).

"The Cuban Poster Crisis." Philip Krayna. *Communication Arts,* vol. 35, no. 5 (September–October 1994): Palo Alto, CA (pages 40–49, with color plates).

"Cuban Poster Project." Irene Small. *Sphere,* vol. 4, no. 1 (1998): New York, World Studio Foundation. Page 15, with color plates.

Decade of Protest–Political Posters from the United States, Vietnam, Cuba 1965–1975. Carol Wells, David Kunzle, and Nguyen Ngoc Dung. Catalog for exhibit at Track 16 Gallery, Santa Monica, CA, organized with the Center for the Study of Political Graphics. Santa Monica, CA: Smart Art Press, 1996 (112 pages, with color plates).

Dimensions of the Americas: Art and Social Change in Latin America and the United States. Shifra M. Goldman. University of Chicago Press, 1994. (No illustrations, but includes an excellent chapter on "Painters Into Poster Makers: A Conversation with Two Cuban Artists.")

"The Film Poster in Cuba (1940–1959)." Eladio Rivadulla Pérez. *Design Issues,* vol. 16, no. 2 (Summer 2000): Cambridge, MA (pages 36–44, illustrated).

La imagen constante: el cartel Cubano del siglo XX [The constant image: the twentieth century Cuban poster]. Jorge Rodríguez Bermúdez. Havana: Editorial Letras Cubanas, 2000 (241 pages text plus 96 pages color plates; No index).

The Latin American Spirit: Art and Artists in the United States, 1920–1970. Essays by Luis R. Cancel, Jacinto Quirarte, Miramar Benítez, Nelly Perazzo, Lowery S. Sums, Eva Cockcroft, Félix Angel, and Carla Stellweg. Published in connection with a traveling exhibition, 1989–1990. Bronx, NY: The Bronx Museum of the Arts, 1988 (343 pages, with color plates).

"Opening a New World for Research on the Americas: Campus, Cuban Librarians Celebrate Historic Pact." Cathy Cockrell. *The Berkeleyan,* vol. 29, no. 7 (September 20–26, 2000): Berkeley (U.C. Berkeley) (page 1, illustrated).

"La OSPAAAL: una muestra de permanencia cualitiva en la gráfica [OSPAAAL: an example of qualitative permanence in graphics]." Roberto Figueredo. *Propaganda,* vol. 10, no. 39 (1982): Havana (DOR of the CCPCC) (pages 37–40, with color plates).

OSPAAAL's Poster: Art of Solidarity. OSPAAAL. Havana: Tricontinental; Varese, Italy: Il Papiro Press, 1997 (204 pages, with color plates; no index).

"Our Man in Havana." Al Gowan. *Print,* vol. XL no. 3 (March/April 1986 issue): Rockville, MD (pages 83–89, illustrated).

Outside Cuba: Contemporary Cuban Visual Artists. Ileana Fuentes-Perez, Graciella Cruz-Taura, and Ricardo Pau-Llosa. Catalog of a national exhibition of the same name, 1987–1989. New Jersey: Office of Hispanic Arts, Mason Gross School of the Arts, Rutgers University, and the Research Institute for Cuban Studies, Graduate School for International Studies, University of Miami, 1988 (366 pages, with color plates; no posters, but good overview of the exile artist community).

"A People's Salute to Cuba." Juan Fuentes and Susan Adelman. Manuscript for presentation at exhibit curated at ASA Gallery, Albuquerque, N.M., 1975 (9 leaves, 44 posters are described, no plates).

"Postrevolutionary Cuban Poster Art." Lincoln Cushing. *Plakat Journal,* issue no. 4 (October–December 1998): Hanover, Germany (pages 25–27, illustrated).

¡Propaganda! Cuban Political and Film Posters, 1960–1990. Maggy Cuesta. Catalog for exhibit in New York, April 12–June 29, 2001. New York: American Institute of Graphic Arts, 2001 (18 pages, with color plates).

"Public Graphics in Cuba: A Very Cuban Form of Internationalist Art." David Kunzle. *Latin American Perspectives,* vol. 2, no. 4, Supplement Issue. (1975): Riverside, CA (pages 89–110, illustrated).

"Retrospective of Top Quality Political Posters." Jorge Rodríguez Bermúdez. *Tricontinental,* no. 134, (May 1996): Havana, OSPAAAL (page 34, illustrated).

A Revolution Apart: Forty Years of Cuban Poster Art. Eric Zolov. Catalog for exhibit September 1–December 10, 1999. Leonard and Mildred Rothman Gallery, Franklin & Marshall College, Lancaster, PA (12 pages, no illustrations).

Rostgaard: A Retrospective: Cuban Revolutionary Posters. Center for Cuban Studies. Catalog for exhibit in New York, July 5– August 31, 2001. New York: Cuban Art Space, 2001 (24 pages, with color plates).
La serigrafía artistica en Cuba [Artistic Serigraphy in Cuba]. Eladio Rivadulla Pérez. Havana: Ediciones Unión (UNEAC, 1996) (140 pages, no illustrations).

"*La serigrafía artistica en Cuba* [Artistic Serigraphy in Cuba]." Eladio Rivadulla Pérez. *Revolución y Cultura,* no. 1–2 (1994): Havana (pages 22–25, illustrated).

"*Sin ingenuidad ni elitismo: cartel de OSPAAAL* [Without Pretense or Elitism: The Poster of OSPAAAL]." Eladio Rivadulla Pérez. *Revolución y Cultura,* no. 5 (1997): Havana (pages 39–41, illustrated).

"Three Essays on Design." Adelaida de Juan. *Design Issues,* vol. 16, no. 2 (Summer 2000): Cambridge, MA (pages 45–61, illustrated).

Treinta momentos: triunfo de la revolución [Thirty Moments: Triumph of the Revolution]. Editora Política. Havana: Editora Política, 1989 (30 loose leaves [folio format] of color plates).

Tricontinental—Selection of posters about Che Taken from the Collections of OSPAAAL and Casa de las Americas. [No author or publisher noted, no date of publication given, circa 1985.] (16 leaves of color plates).

"*Un cartel para tres continentes* [A Poster for Three Continents]." Jorge Rodríguez Bermúdez. *Tricontinental,* no. 133 (January, 1996) (pages 32–37, illustrated).

★

INDEX OF POSTERS BY TITLE

ACKNOWLEDGMENTS

IMAGE SOURCES

Most of these images are chosen from posters in the Docs Populi archive (my personal archive in Berkeley that extends the work begun while I was codirector of the Cuba Poster Project). The rest are from other U.S. archives; the Center for the Study of Political Graphics in Los Angeles (posters 3, 4, 16, 21, 36), the collection of David Kunzle (now part of the CSPG collection), the personal collections of Jane Norling (posters 13, 30), and the Michael Rossman collection in Berkeley (posters 8, 10, 18), and almost all of the ICAIC posters are from the private collection of Alan Flatt in Oakland, California. A large number of the EP images are digital scans made from slides loaned by that agency. In many cases, there are no known surviving copies of the original poster, and the digital reproductions are the only format for presenting the images. Some of the source slides for these scans were in such poor condition that they required varying levels of digital enhancement, which was guided by representation of the poster's original "look and feel" more than archival fidelity.

In *Winning the War Bread Is Just as Important as Bullets,* (MC-War Food Posters, page 16) provided courtesy of the Oregon State University Archives.

All photographs © the author, except for photo of Raúl Martínez (page 119 center) by Eva Cockcroft, photo of Havana pharmacy (page 13) by Cindy O'Hara and Christmas card photo of Gertrud Ludtke and Luis Martínez-Pedro, whose photographer is unknown.

PEOPLE AND INSTITUTIONS

This book has been many years in the making and would never have come about without the support and encouragement of Steve Mockus and the Chronicle Books crew. As for the community that made it possible to pursue this path, I wish to offer my deepest thanks to many friends, colleagues, and comrades. Betty Kano, for getting me to go to the 1989 Bienal de La Habana; Carol Wells and David Kunzle, who accompanied me on exhilarating scavenger hunts in Havana and beyond; Dan Walsh, for his commitment to bringing oppositional poster art to the American public; Karen Wald, dedicated journalist who helped as in-country liaison. Reinaldo Morales Campos, former head of the

OSPAAAL warehouse and protector of Cuban posters; Gail Reed and Graciela Tabio, dedicated Arca Foundation staff in Havana; Julie Ruben, Cuban film industry expert and able research assistant; Sandra Levinson, an eternal flame in the presentation of Cuban culture in the United States; Michael Rossman, who taught me to take this seriously; Tim Drescher, who always offered useful and critical comments; Alan Flatt, whose generosity and foresight in building his poster collection made it possible to include almost all the film posters in this book; Georgina Chabau, whose support of cultural activism coupled with her respected role in the Cuban circles of power opened doors for me; and Robbin Henderson of the Berkeley Art Center, who made an exhibit of these gems possible. I also wish to thank the agency directors and staff at OSPAAAL, ICAIC, and EP for sharing Cuba's cultural heritage with me. I must also acknowledge the generous support and help provided by director Eliades Acosta Matos and the staff of the José Martí National Library. Many thanks to all of the individual artists who helped me check facts, confirm authorship, and in general shared their professional lives with me over *cafecitos* and glasses of rum—Lázaro Abreu, Gladys Acosta, Eduardo Muñoz Bachs, Alberto Blanco, Nestor Coll, Olivio Martinez, René Mederos, Eladio Rivadulla, and Alfrédo Rostgaard. And finally, I wish to thank my wife, Nina Robinson, and children, Ellen and Robby, for putting up with my late night crabbiness when shooting posters or pounding on the keyboard.

This book is dedicated to two artists who lived in Cuba and are responsible for engulfing me in this mild obsession. The first is my mother, Nancy Cushing, who encouraged me to pursue the passion of art and gave me my first Cuban poster. The second is René Mederos, who embodied the deepest essences and human contradictions of a true revolutionary artist. He was talented, humble, smart, dedicated, hardworking, and sweet. Both were powerful artists and wonderful human beings, and they will be missed.